ADVANCED

Digital Camera Techniques

JACK *and* SUE DRAFAHL

AMHERST MEDIA, INC. ■ BUFFALO, NY

DEDICATION

We would like to dedicate this book to all the photo instructors, magazine editors, and professional photographers who have helped guide and shape our photographic careers. Thanks for all of your help.

Published by:
Amherst Media, Inc.
P.O. Box 586
Buffalo, N.Y. 14226
Fax: 716-874-4508
www.AmherstMedia.com

Publisher: Craig Alesse
Senior Editor/Production Manager: Michelle Perkins
Assistant Editor: Barbara A. Lynch-Johnt

ISBN: 1-58428-099-9
Library of Congress Control Number: 2002113009

Printed in Korea.
10 9 8 7 6 5 4 3 2 1

Contents

ABOUT THE AUTHORS

Jack and Sue Drafahl are a husband and wife team of professional photojournalists, lecturers, and multimedia producers. For over thirty years their articles have appeared in *Petersen's PHOTOgraphic, Rangefinder, Sport Diver, Focus on Imaging, Outdoor Photographer, National Geographic World, National Wildlife Federation,* and *Skin Diver Magazine.*

They have been actively involved in the digital transition since the early '80s and are software and hardware beta testers for companies like Adobe, Applied Science Fiction, Corel, and Ulead Systems.

Their audio-visual presentations have been shown at film festivals from coast to coast on topics that span the range of underwater and nature photography. They also produce multimedia presentations for numerous award ceremonies around the world.

Jack and Sue make their home on the Oregon coast and enjoy teaching seminars worldwide on all aspects of photography, both topside and underwater. In addition to their various monthly articles, Jack and Sue have authored *Digital Imaging for the Underwater Photographer; Photo Salvage with Adobe Photoshop;* and *Step-by-Step Digital Photography: A Guide for Beginners* (Amherst Media).

For more information on the authors, or to view additional images by the Drafahls, please visit their website at www.jackandsuedrafahl.com.

1. Introduction

Not too far in the future, film photography may be referred to as "the old silver process." The chemically-sensitized emulsion is quickly being replaced with an electronic CCD (Charge-Coupled Device) or the newer CMOS (Complementary Metal Oxide Semiconductor) light-sensing device. Digital cameras are changing the way we view photography since we can see our results instantly.

Photographers are thrilled with instant feedback. With digital cameras, LCD (Liquid Crystal Display) screens provide instant previews. This is not a new concept, however; it dates back to Edwin Land's 1947 invention of the Polaroid camera. Once you took an image with this camera, the film developed right before your eyes, and the final picture was visible in less than a minute. Professional photographers thought this was great as it allowed them to modify exposure, lighting, focus, and other technical aspects during the photo session.

> Today's digital cameras help photographers expand their creative and technical skills.

Today's digital cameras help photographers expand their creative and technical skills. Digital cameras allow through-the-lens viewing so you can see exactly what you are photographing. Even close-ups and movies are possible with these technological wonders. Best of all, the new digital SLR cameras have both the optical preview that film cameras have, plus the ability to review and correct mistakes via the LCD viewer on the back of the camera. Surprisingly, these are just a few of the reasons why so many people are making the switch to digital.

We started our photographic careers more than thirty years ago, and have exposed tens of thousands of film images, from open-heart surgery to the depths of the ocean. Through our extensive film testing with *Petersen's PHOTOgraphic* magazine, we have tried just about every emulsion made. This evolution of film has provided us wide-ranging technical and creative control over our images, but we try to remain open-minded, ready to embrace new ideas.

We both loved the advances in photographic technology in the mid-'90s, and eagerly tried those very expensive, low-resolution digital cameras when

they first appeared. They were exciting and innovative, but still left something to be desired. Since then, a technology explosion has produced some very high quality compact digital cameras that will literally fit inside your pocket. As the quality of these cameras soared and the prices dropped, we started to make the transition from traditional film to digital cameras.

During our investigation into this technological revolution, we realized there was a distinct need for a book on digital camera techniques. Too many photographers were being forced into a technology overload. We wanted to give them a hand in adapting from film to digital and show them that digital can be used to create some new and dynamic images—some not even possible with film.

The problem we encountered in creating this book was technology itself. Unlike progress made in film emulsions, which moved slowly and was easy to accept, advances in digital photography come at lightning speed. It becomes almost impossible to talk about a certain product before it has been replaced with something better. In the time it takes to publish this book, you may even find that some of the camera models illustrated here have been replaced.

Fortunately though, most of the digital camera's features have remained constant. Image compression, white balance, image size, and LCD viewers were featured on the very first digital cameras and continue to appear on each new model. Just use your imagination if you find us depicting a digital camera feature on an older camera model.

The mind behind the camera's eyepiece still controls the art of imagery.

The basic concept of photography—the capture of an exposure on a light-sensitive device—is still controlled by shutter speeds and f/stops. The mind behind the camera's eyepiece still controls the art of imagery. Those things will never change.

The photographic techniques necessary to take pictures have changed slightly to adapt to this new technology. Our goal is to show you why digital is becoming so popular and then progress to basic digital camera operation. With that accomplished, we will then explore the wonders of the digital world. We hope you enjoy this new technology as much as we do.

2. Film vs. Digital

When the digital camera first appeared, there were many heated discussions between die-hard film photographers and the advocates of the world of digital. Initially, the arguments favoring film had the upper hand, but eventually, with the improvements in digital camera design, digital started gaining ground. Today it is strictly a matter of attrition as very few film cameras are being replaced with another film camera. There have been very few new film emulsion introductions, and new film camera sales are slowly losing out to digital. Digital is like a freight train and it is quickly coming down the track. Like it or not, you better not stand in its way.

For those who still need convincing, here are some of the reasons why so many people have gone into digital. While there are many more arguments for buying a digital camera, these should convince the bulk of the photographic population of its merit.

Digital is like a freight train and it is quickly coming down the track.

● INSTANT FEEDBACK

When you shoot film, you must finish the roll, drop it off for processing, and later preview the final images. In most cases, you don't see the results until long after the shot can be retaken because the camera didn't work properly, or you accidentally set the camera controls improperly. Since most people don't keep records of the camera settings used for each film frame, it makes it even more difficult to correct any mistakes. You may find yourself making errors like overexposure, cut-off heads, or out-of-focus images over and over again.

The digital camera changes all that with two features not found on film cameras. The first is the LCD, which allows a preview of the image less than a second after you take the shot. If there is something wrong with the image, you know it right away. You can correct the exposure, re-frame the subject, or zoom in for a tighter shot. If you're unsure about an accurate focus, you can zoom in and look at an enlargement on the LCD viewer. You will immediately know you've made an error, exactly what the mistake was, and you can re-shoot the scene before the subject has moved away.

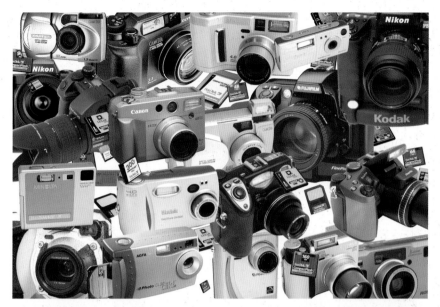

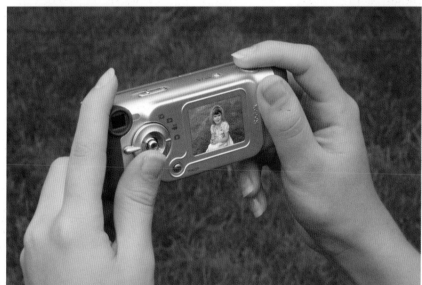

Top—Since digital cameras need not conform to fit the 35mm film cassette, you can find them in every shape and size. They vary from point & shoot cameras to digital SLRs and range from 2 to 6 megapixels and beyond. They don't use traditional film; instead, they utilize memory cards, which enable you to take more images in a single photo session. **Center**—The biggest advantage of the digital camera is that you can take a picture and then view your results with the LCD viewer on the back of the camera. Even the lowest-priced point & shoot cameras provide the WYSI-WYG (what you see is what you get) LCD screen found in SLR cameras. **Bottom**—Most digital cameras today use either the CompactFlash (left) or the Smart Media memory cards. Some cameras even have the ability to take both cards at the same time.

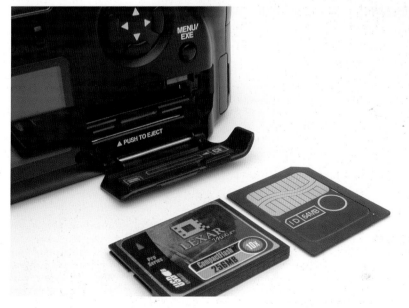

The second feature is in the digital file itself. With almost every digital camera made today, an information file about the camera settings used is saved with the photo. When you review your images, you can look at these camera settings and apply that information to correct any reoccurring mistakes.

○ NO SCANNING REQUIRED

The popularity of the Internet has created a need for converting images to digital files so they can be transmitted to family and friends. Film images must be placed in a film scanner and balanced for color and exposure before a one- to four-minute scan is made. Additional corrections may need to be made before the digital image is acceptable.

Digital cameras make scanning unnecessary because the image is converted when it is taken. The file is contained internally on the digital storage device and must then be transferred to the computer. This can be done via a communications link or by inserting the removable storage device into a memory card reader hooked directly into your computer. This is a quick process, and most images need very little correction before they can be sent over the Internet.

> Most images need very little correction before they can be sent over the Internet.

○ NO FILM OR PROCESSING

If you look at the cost of film and processing, two to four rolls will be equal in price to a medium-sized memory card of 128 megabytes (MB). Most of these cards can hold one image per megabyte. According to manufacturers, these cards can be used more than 1,000 times, so if you do the math, you can have at least 128,000 photos for the price of four rolls of film.

When you drop off film for processing and printing, you generally get all the images printed, good or bad. The only way to avoid this is to process the film first, and then select only those images you want printed. With the new one-hour digital printing services being offered virtually everywhere, you can select only those images you want printed from your card and save on printing costs.

You can also archive your digital camera files on CDs or DVDs. These provide compact storage for large volumes of images, and they can last up to 100 years or more, which exceeds the life span of most films or prints.

○ COMPACT CAMERA

Because digital cameras don't have to conform in shape to accommodate a film cassette, you will find them in every size and configuration. They are very ergonomic, and many are so small that they will fit in a purse or shirt pocket. Even with this small size, the image quality allows for prints

Above—Images can be previewed on your television via a special video cable. In most cases, the video jack is located on the side or back of the digital camera. Some of the more advanced-level digital cameras will even have a slide show function that adds effects as the images are previewed. **Right**—Memory cards can hold up to hundreds of digital images, which equates to many rolls of film. The cards can be erased and reused time and time again. The card storage capacity depends on the image resolution and file compression used.

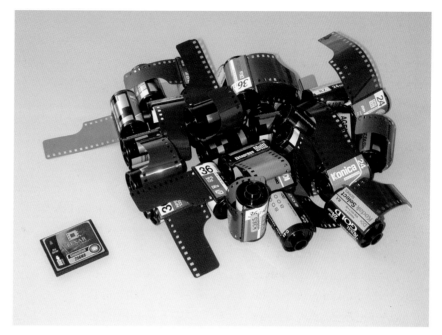

beyond 8 x 10 inches when the resolution of the camera is 3 megapixels or more.

○ TV PREVIEW

Unique to digital cameras is their ability to play back your images on a television. This is accomplished by hooking up a single video cable from the camera to the TV input video jack. This is great for parties, as you can take pictures and show them within minutes, so everyone at the party can enjoy your photos. You can even record the images on video tape or DVD and play them back on the television.

○ NO GRAIN

Unlike film, digital camera images do not have grain. Some of the original camera models had some digital noise at the higher ISO ratings, but most have now eliminated this problem. If you decide to enlarge your digital files to a point where file compression jaggedness shows, there is even fractal compression software available that can be used to minimize the jaggies.

○ VARIABLE ISO SPEED

With film cameras, you had to change to a higher ISO film when the light level dropped in intensity. This was difficult when you hadn't finished your full 24 or 36 exposures. With digital, you merely set the camera to auto ISO, or manually increase the ISO as the light level drops from one shot to the next. Set on auto, the camera will sense when the light level drops and automatically change the ISO speed.

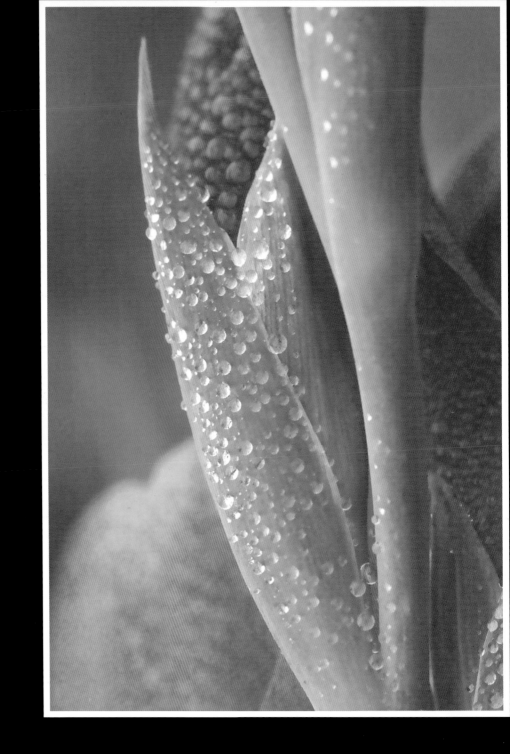

Opposite—The ISO technology of the digital camera now ranges from ISO 80 to 1600 in most amateur and semi-professional-level models. The professional level cameras have up to ISO 6400, as shown in this image taken in the early morning without flash. The exposure was ¹⁄₄₀₀₀ second at f/10. **Above**—Another big advantage of the digital camera is that you can change your ISO from one image to the next. With a film camera, you must take the remainder of a roll or remove it, unexposed, to change the ISO setting.

● COLOR TEMPERATURE/WHITE BALANCE

Film images taken under tungsten, fluorescent, or other lighting sources require that you either change to a special film, or use correction filters to balance the light source to the film. Digital cameras use a function called white balance that automatically senses the color balance of the light. You can also manually select a specific light source from the white balance menu. See chapter 3 for more information on white balance.

● AIRPORT X-RAY AND FILM

With the increased security at airports today, the chance of your film being fogged by x-ray machines has increased. Most airports in the United States will allow hand-checking of your film, but flying internationally with film can be risky. Digital cameras and memory cards are unaffected by the airport x-ray machines, so they make great travel partners.

● LOW LIGHT EXPOSURE

Even though film and digital ISO speeds are similar, you will find that digital cameras do a better job of recording low light situations. This is especially noticeable in the mid-tone areas where film tends to fail in low light.

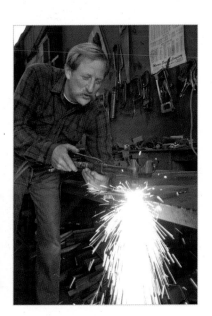

Left—Digital cameras work better in low light, even when you have a variety of mixed lighting sources in the scene. The exposure of this welder was ¹⁄₆₀ second at f/8 at ISO 800. **Right**—Shooting with film under different light sources requires the use of color correction filters or a special light-balancing film. Digital cameras have a special feature to balance the light. You can set the white balance to automatically sense and correct the color balance, or you can set it to a known type of light source.

3. Digital Camera Basics

In this chapter, we'll look at the main operational differences between film and digital cameras. We'll present a nutshell explanation of each so that you can better apply them to your new digital camera. The following information is fairly generic and should apply to most any digital camera model. If you need a more in-depth guide on the full inner workings of your digital camera and its operation, you might consider our companion book, *Step-by-Step Digital Photography: A Guide for Beginners,* which is also published by Amherst Media.

● RESOLUTION

One of the most confusing aspects of the digital camera relates to the quality of the digital image itself. This is where terms like *image resolution, file compression,* and *image sharpening* surface. We recommend that you use the default settings on all features until you become better acquainted with your digital camera's functions. You will have plenty of time later for experimentation.

The following information should apply to most any digital camera model.

First, let's start with image resolution. In most cases, you will want to leave your camera set to the highest resolution setting, which is usually the default. Most digital cameras will have lower resolution settings, but we don't recommend using them. You will be disappointed if you decided to make a big enlargement from your low-resolution file. We only resort to using the lower resolution setting if we are running out of memory card space and absolutely have to get the shot.

You should use the highest resolution setting, even if you are taking the pictures for use on the Internet. If you need a lower-resolution image, you can always bring the file into your favorite image editor and reduce the file size for Internet usage.

● COMPRESSION

Image compression is even more confusing than resolution. Uncompressed digital files can take up a lot of memory card space, so digital cameras offer

A digital camera allows you

to modify the sharpness as it

records your image.

various levels of image compression. As the compression level increases, the image quality starts to degrade. This will scare a lot of people into resetting the compression from the default, which is usually in the middle, to a lower compression (low compression equals high quality, while high compression equals lower image quality). If you compare an image set to the middle compression to one set to low compression, you will see very little difference. Even if you decide to enlarge the image, there are software programs like Genuine Fractals from Lizard Tech, Inc., that allow you to work with a small file size and still achieve a high-resolution output.

○ SHARPNESS

A digital camera allows you to modify the sharpness as it records your image. On most cameras, the default setting is toward the middle of the sharpness scale. This setting is predetermined by the camera manufacturer to provide the optimum image quality possible with that camera. If you need to further increase the sharpness, you can use a sharpening filter, located in most editing programs.

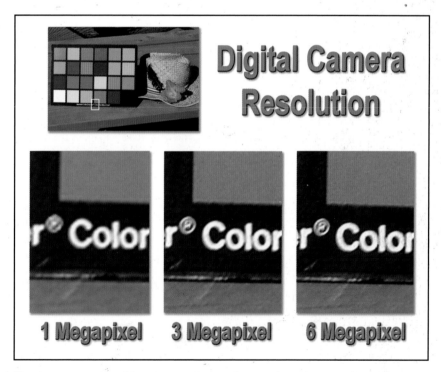

This shows a comparison of digital camera resolution from 1 to 6 megapixels. As you can see, there is noticeable difference from 1 to 3, but very little from 3 to 6 megapixels. This indicates that cameras above 3 megapixels are suitable for most digital camera applications.

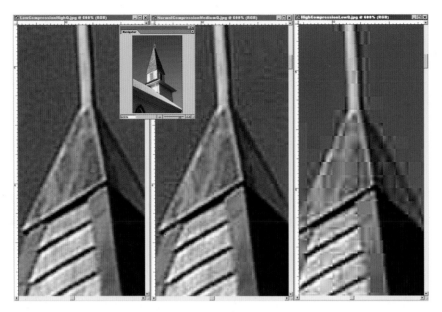

This is a comparison of different levels of JPEG compression. The left image represents the lowest level of image compression, which provides the highest level of image quality. The right image uses the highest level of compression, which yields the lowest image quality. Most digital cameras are set to a middle JPEG level setting as a default because it is the best compromise of image quality and file size.

DIGITAL ZOOM VS. OPTICAL ZOOM

An optical zoom changes the focal length of the internal lens of your digital camera. This modifies your field of view as you zoom from wide-angle to telephoto. An image shot in wide-angle mode will be just as sharp as one made in telephoto mode if the camera is held steadily.

A digital zoom only takes part of your image and magnifies it to give the illusion of zooming. We do not recommend using the digital zoom function, as you lose image resolution due to the camera's internal cropping.

SHUTTER DELAY

The number one complaint with the point & shoot variety of digital cameras is shutter delay. Basically, a digital camera has to run through many operations before the shutter opens and closes, and this causes a time lag. As you press down on the shutter release, the camera must calculate exposure, focus the camera lens, and then switch the LCD viewer from the viewing mode to shooting mode. In some cameras this can take as long as a full second before the shutter fires.

Most of the time, this delay can be overcome with a couple of digital camera tricks. Since the focus system expends the most time, there are two possible solutions for solving this problem. First, you can press the shutter release halfway down, and the camera will pre-focus the lens. When you finally depress the shutter, there is almost no delay in the shutter release. It

The number one complaint with the point & shoot cameras is shutter delay.

also helps if you can anticipate the height of the action as your camera is pre-focused and ready to go.

An alternate solution requires that you venture into the menu system of your camera. This may even require that you look through the instruction manual. Check the focus settings to see if your camera can be set on continuous focus. This means that the camera will constantly be searching for the correct focus. This allows you to be ready to shoot even when the shutter isn't pressed down halfway. The downside to this solution is that the lens is constantly moving, the battery depletes faster, and it takes a little longer to focus, as the camera will still make one final focus verification.

Left—This image illustrates the problem with shutter delay. Right after the shutter was depressed, the photographer moved the camera, thinking the picture had been taken. In fact, the image was taken a full second later. **Right**—Here, the photographer pressed the shutter halfway down in advance. The image was taken a fraction of a second later when the photographer fully depressed the shutter button.

○ BATTERIES

Many of the original 35mm film cameras didn't require batteries or required only a small hearing aid battery to run the internal meter. Today's digital cameras are power hungry. The LCD viewers, focus controls, and memory devices all consume tremendous amounts of power. You will quickly find that standard alkaline and NiCad batteries will not work well in a digital camera. Your only choice will be lithium, Ni-MH, or proprietary batteries that come with the camera.

If you find that you still need to conserve power, you can turn off the LCD preview and use the optical viewfinder. Internal flash units also consume power, so if your camera will support an external flash, you can use it in lieu of the internal flash. Generally, the external flash will do a better lighting job anyway.

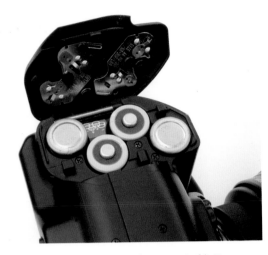

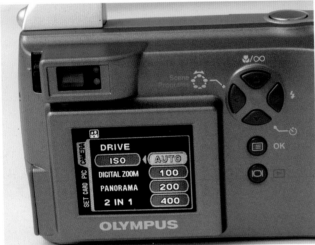

Top Left—Digital cameras use a tremendous amount of battery power and require the use of lithium or Ni-MH rechargeable batteries. The Ni-MH batteries work well but must be recharged on a regular basis as they don't hold a charge very long when not in use. **Top Right**—Care must be taken to make sure that you follow the + and – signs on the battery compartment when inserting camera batteries. If they are inserted incorrectly, your camera will not function or will report an error. **Left**—Most ISO menu screens have the choice of setting your camera to auto or a specific speed. When you are unsure as to which setting to use, auto would be the best choice. As you become more familiar with your camera, you can then apply specific ISO speeds to match your picture-taking style.

○ WHITE BALANCE

With film, you have to use special color balanced film or color correction filters for each type of unique light source. Digital has a nice feature called *white balance,* which allows you to adjust color balance as you shoot. The default setting for most digital cameras is called *auto balance,* where the camera automatically determines the color balance of the scene and applies it as the image is taken. If you know for sure that the color balance is other than sunlight, you can manually set it to tungsten, fluorescent, or flash. Some cameras have additional settings for multiple types of fluorescence, shade, and mixed lighting situations.

○ DIGITAL ISO

One of the most frustrating aspects of shooting film was deciding which film to use. As soon as you loaded a specific film speed, you would find that the lighting changed. You then either had the option of taking your chances and using the film anyway, or unloading the partially exposed roll and loading a different ISO.

Digital cameras generally

have ISO speeds ranging

from 100 up to 6400.

Digital cameras generally have ISO speeds ranging from ISO 100 up to ISO 6400 (professional level), so you have options. If you set the ISO speed to auto (normally the default), the camera will sense the level of lighting and set the ISO speed accordingly. If the light level drops, the ISO will rise.

You can also manually adjust the ISO speed from one shot to the next by using the ISO control on your digital camera. The disadvantage of increasing the ISO is that the resulting images may pick up a small amount of digital noise in the process (much like film grain).

○ IMAGE ADJUSTMENT

These features generally modify the image contrast, saturation, and brightness. You may find them grouped together or in separate menus on your camera. In most cases, you should leave the camera brightness and satura-

Low light and mixed light sources require a high ISO setting and florescent white balance setting on the camera.

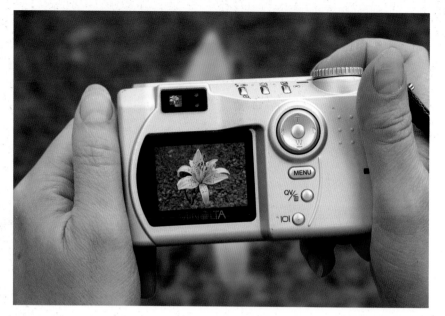

The key to getting great shots is knowing when to use the two camera viewfinders. For close-up images, the LCD on the back of the camera is the best choice, but distant photos work just as well with the optical viewfinder on top of the camera. On bright, sunny days you may have difficulty seeing the LCD viewer on the back, so the optical viewfinder may be your only choice. You can always review your images in the shade where the image on the LCD screen is more visible.

tion controls set to the default setting (usually auto or normal). We have found that the normal contrast setting on most digital cameras is usually a little higher than most people like and tends to lose detail, so set it to one level below normal. If you shoot on the lower setting and find an image too flat, you can always increase the contrast later in a photo editing program like Adobe Elements or Adobe Photoshop.

⊙ DUAL VIEWFINDERS

One of the first mistakes people make with digital cameras is to use the LCD viewer for all pictures. It is very valuable, but when shooting general scenes in sunlight, you will find it easier to use the optical viewer on the top of the camera. The bright sunlight often makes it difficult to clearly see the image in the LCD viewer. You can purchase sunshades that wrap around the LCD to better shield the sunlight or, in a pinch, cup your hand to shade the screen.

The LCD viewer should definitely be used when taking close-ups, or when critical data is near the edge of the photo. It is also invaluable for determining whether you achieved a correct exposure or not.

A fairly new concept with some of the newer digital cameras is having dual LCD viewers, one on the back of the camera and one inside the top viewfinder. When the sun is too bright to see the image on the back LCD, you can switch to the one inside the viewfinder. You can even preview the images you have already shot, and delete any you don't want to save. Because the image in the viewfinder LCD is smaller, the image is usually not as clear as with an optical viewfinder. Therefore, critical image scrutiny must still be done with the larger LCD viewer.

4. Exposure Modes

One of the most misunderstood features of a digital camera is the exposure mode control system. Available on almost every digital camera made today, these controls consist of program, aperture, shutter, and manual. Familiarize yourself with all these controls so you can properly decide when to select the different functions.

● PROGRAM MODE

The easiest way for a photographer to use their new digital camera is to set it on program mode. The camera does everything automatically in this mode, and the term *point & shoot* really applies. For the bulk of most photo situations, the program mode does a great job, and you don't have to work very hard to get a great picture. However, problems occur when the photographer assumes that the camera always makes the best decision. The program mode provides an exposure that is adequate for most general exposure situations, but it doesn't take into account subject movement or the extreme depth of field often necessary for close-ups. That's why your camera offers the other exposure controls.

For the bulk of most photo situations, the program mode does a great job.

● APERTURE MODE

When you switch to the aperture mode, you are in control of the depth of field in an image, because you have the ability to select a specific f/stop. The camera will select an appropriate shutter speed that will result in a correct exposure. This sounds like a great solution, but it can also create problems: since you have no control over the shutter speed, it may be so low that the resulting image is blurred.

Not to worry, however—fortunately, the solution is as simple as locating the small lightning bolt and turning on the flash. Since the duration of a flash is around $\frac{1}{1500}$ of a second, you can now freeze the movement and still maintain your depth of field. If you are in a situation where a flash won't help, then you may need the assistance of a camera tripod to minimize camera shake.

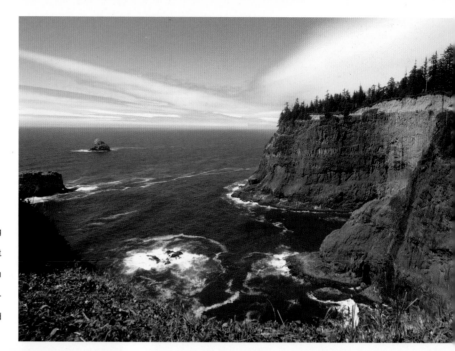

Right—This is a lovely viewpoint overlooking the Pacific Ocean, not far from our home. It was taken with the camera set to program mode using a very wide-angle lens on our digital SLR camera. The exposure was $^1/_{500}$ second at f/13.

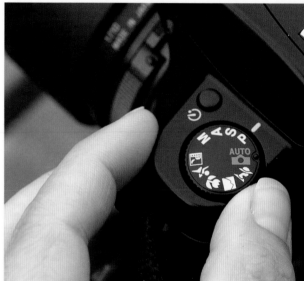

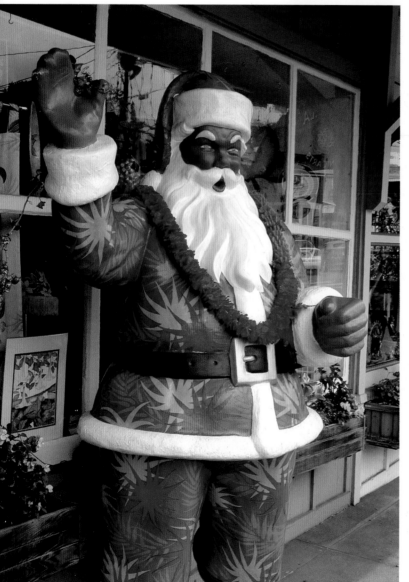

Left—This Hawaiian Santa image was taken in the program mode, which allowed the camera to select both the shutter speed and f/stop. The exposure here was $^1/_{250}$ second at f/11. **Above**—The exposure mode control can be found on a rotating dial on the top of the camera on most digital models. If it is not there, you will find it located in a camera menu.

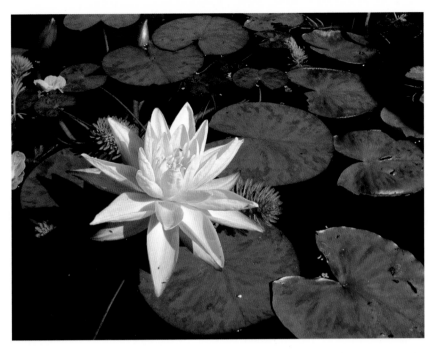

Our attempt to photograph a water lily in a small fishpond required the use of the aperture mode to ensure that both the flower and the leaves in the distance were in focus. The camera was set to ISO 200 to obtain an exposure of $\frac{1}{200}$ second at f/16.

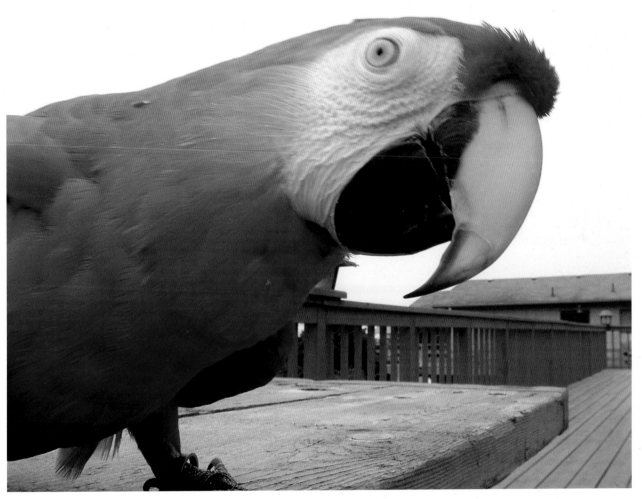

An outdoor portrait of our pet Scarlet Macaw required the use of the aperture mode to ensure adequate depth of field. The camera was set to ISO 400 with an exposure of $\frac{1}{125}$ second at f/16.

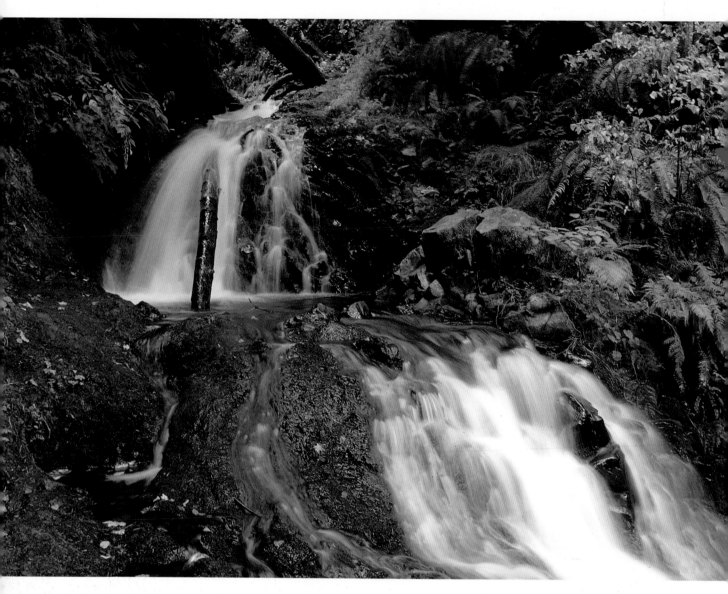

Common subjects for the aperture mode include small critters and por-
traits when you have people both near and far. This mode will be invalu-
able when you have a perspective wide-angle shot with a small object close
to the camera and you want it in sharp focus.

○ SHUTTER MODE

When the action gets high, you will need to switch to the shutter mode so
that you can select a specific high shutter speed to stop the action. You can
adjust the shutter speed dial to any speed you want and the camera will
readjust the aperture to guarantee a good exposure. The problem is that you
may get a warning on the LCD display indicating that the camera is already
at its widest aperture, and there is not enough light for a proper exposure.
So, now what do you do?

Well, at this point you have two choices. You can reduce the shutter
speed until you achieve an acceptable exposure. If that results in a speed too

We set up a tripod in deep shade near a water-
fall in the Columbia Gorge. After several tests
at different speeds, the final image was shot
at two seconds with the camera selecting f/22
as the appropriate aperture setting.

low to stop the action, you can increase the ISO rating. This higher ISO will allow you to increase the shutter speed in equal increments. For example, an increase of ISO 100 to ISO 400 will allow you to increase your shutter speed from $\frac{1}{125}$ second to $\frac{1}{500}$ second.

The downside to using the shutter mode is that you have no control over the depth of field. You need to switch back to aperture mode if depth of field is your primary concern.

The shutter mode also offers you creative control by allowing you to select the shutter speed to achieve long exposures. One of our best examples of this dreamy effect is a photograph we took of a cascading waterfall located in deep shade. After mounting the camera to the tripod, we set the white balance to shade to eliminate the blue cast. We then set the shutter speed from one to four seconds in duration and set the ISO to a lower setting if the camera indicated overexposure.

⊙ MANUAL MODE

The manual exposure control is for photographers who have a good understanding of photographic exposure and want full control of both depth of

The powerful wave action on the Oregon coast was captured with the SLR digital camera and a 75–300mm zoom lens set to shutter mode. A $\frac{1}{2000}$-second shutter speed with ISO 800 forced the camera to select f/8 as the correct aperture.

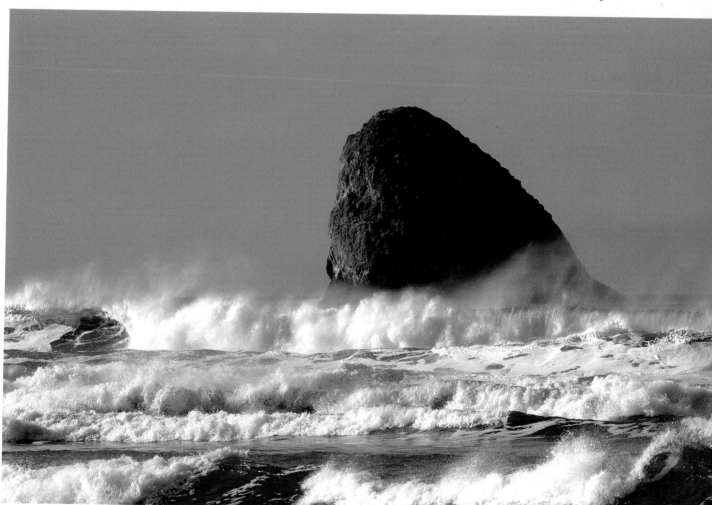

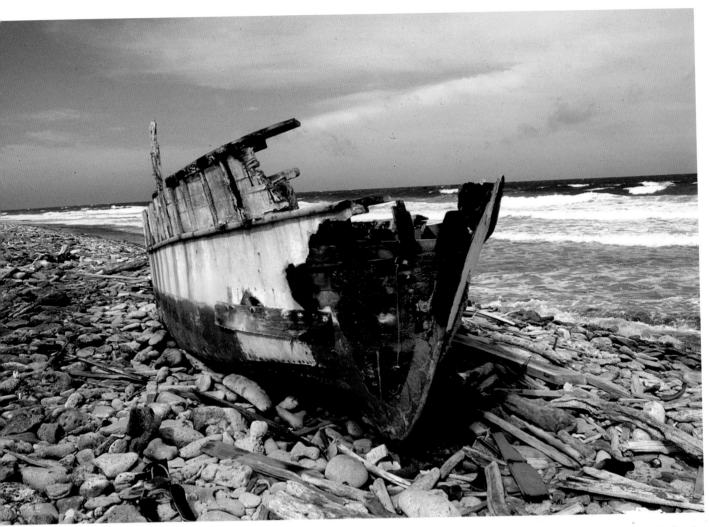

field and action-stopping ability. In the film world, the photographer using manual exposure had to wait for the film to be processed to see if their creative skills really worked. The digital camera, with its LCD viewer, makes it easier to use the manual mode, as you can repeatedly preview and shoot until you have the desired effect.

There are a few photo situations that require the use of the manual mode, as the program, aperture, and shutter modes can't accurately analyze the scene. A backlit scene where the sun is peeking around the corner of the subject is just one example where the manual mode excels.

We discovered this old boat along the Bonaire Island coast. If we had used the program mode, the bright sky would have influenced the final exposure. Instead, we used manual exposure to ensure that the inside of the damaged boat was visible. The camera was set to ISO 400, with the shutter speed set to $\frac{1}{125}$ second and the aperture at f/16.

○ OTHER USEFUL MODES

Now we come to the specialty exposure controls, which are actually biased versions of the program mode. They are not found on every digital camera, but if you have them, you will quickly see that they can be a great help in achieving exposure control.

Close-up or Nature. If you bias the program control so that it favors depth of field, you will have the close-up or nature exposure mode. If you find you

like using the program mode but want control over the depth of field rather than the action, then this mode would be a good choice. Remember that it will select the smallest aperture possible, but will vary it if required to achieve a good exposure.

Sports. The sports mode works much like the program mode, except its primary concern is providing a high shutter speed to stop the action. It will select the highest possible shutter speed, but will lower it if deemed necessary when the light level drops.

Portrait. The portrait mode is unique. Rather than maximizing depth of field like the close-up or nature mode, this mode keeps the aperture close to wide open. This allows the background to be out of focus, thus creating more emphasis on the subject.

Landscape. Another mode you may find on your exposure dial is the landscape mode. This control is more concerned with depth of field than with controlling subject movement. Its bias is somewhere between the program and nature or close-up mode, which results in apertures in the upper $\frac{2}{3}$ of the f-stop scale, so as to capture the extreme focus range found in landscape photography.

 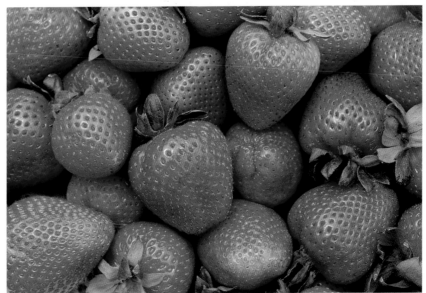

Left—The close-up mode was used in full sunlight with the camera set to ISO 200. The camera selected f/16 at $\frac{1}{200}$ second as the best combination for maximum depth of field and minimal camera movement. **Above**—Overcast skies made the close-up mode the best choice for this image of strawberries. To ensure the best depth of field at ISO 200, the camera selected an exposure of f/16 at $\frac{1}{100}$.

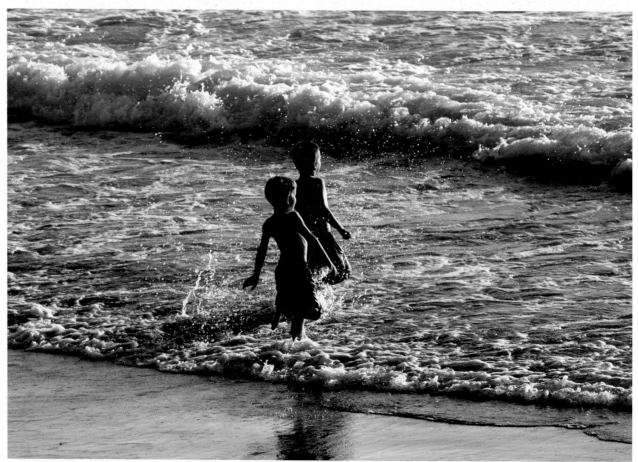

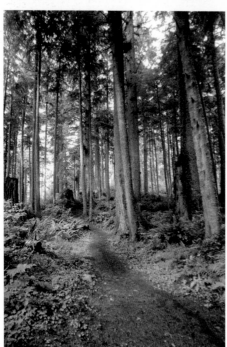

Above—Late afternoon sun provided enough light for the sports exposure mode on a digital SLR camera to freeze these kids in their tracks. Using an ISO 400 rating, the camera selected a $1/1000$ second at f/6.3 setting to stop the action.

Left—Even with the low light levels in this forest scene, when the landscape exposure mode was selected, the camera picked the maximum depth of field without setting the shutter speed too low. With the camera set to ISO 800, it selected $1/50$ second at f/11. **Right**—To ensure that all detail in the background was out of focus, the camera was set to the portrait exposure mode. With the camera set to ISO 400, it selected $1/500$ second at f/8 as the best setting for this portrait.

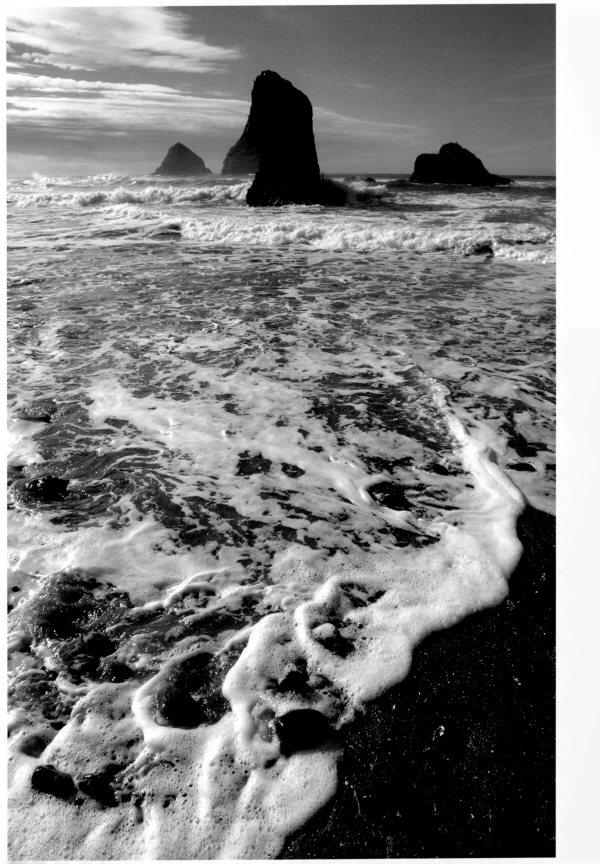

5. Depth of Field

The depth of field in a picture refers to the area that is visually sharp in front of and behind the focus point. As the aperture in the lens becomes smaller, the depth of field increases. The ratio for this focus area is not evenly spaced as you might think. The photographic laws of physics dictate that focus is ⅓ in front of and ⅔ behind the subject. This is why you see more subjects in the foreground rendered out of focus than distant subjects.

Depth of field also changes with the focal length of your camera lens. As the angle of view becomes wider, the depth of field increases. When you extend the lens to telephoto, the depth of field decreases.

As the aperture in th

becomes smaller, the

of field increases.

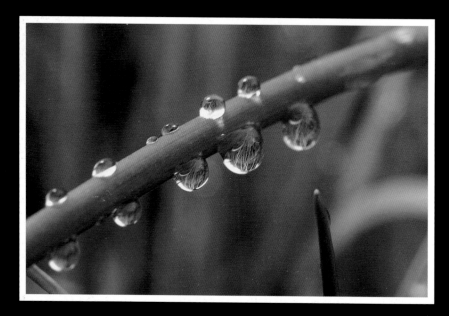

Minimum depth of field was necessary in this shot of dew on grass to keep the background out of focus. The camera was focused on the secondary images formed in each drop of dew.

● USING DIGITAL

The new twist to the depth of field equation comes with digital point & shoot cameras. Most of the models sold today are engineered with chips that are about ¼ the size of the 24 x 36-millimeter film frames. This means

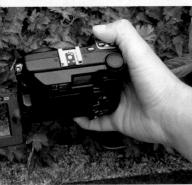

Above—A digital SLR camera with a very wide-angle lens was focused on a point one third the distance down the airplane wing. The f/stop was set to f/16 to ensure maximum depth of field from the tip of the wing to the fuselage of the plane. **Left**—Many of the point & shoot digital cameras have flip-out LCD viewers that allow you to easily preview your image and check the depth of field from various angles. You can even magnify sections of the image to verify that all the subjects are in focus.

the depth of field in a digital point & shoot camera is four times greater at the same f/stop than a 35mm film point & shoot camera. This is really handy, because if you used f/16 to achieve a specific degree of depth of field on a 35mm camera, you now only need f/8 to get the same depth of field.

○ PREVIEW MAKES IT EASIER

Depth of field with a digital camera is actually much easier to see than with a film camera, thanks to the preview function. Most film cameras have a depth of field button, but the image appears dark as the lens stops down,

and it is hard to determine the actual depth of field until you process the film. With a digital camera, you can preview the image in the playback mode and zoom in to check focus. If the final image is just what you wanted, then you are done. Otherwise, make a change to the f/stop or shutter speed control and give it another try.

○ CREATIVE APPLICATIONS

Perspective. Now, let's apply this knowledge of digital depth of field to some creative applications. Our first assignment is to use an object in the foreground to create some perspective and give the photo a three-dimensional effect. You will want to press the zoom control on your camera until the lens is at the widest angle. Move in as close to the subject in the foreground as possible, making sure that it is still in focus. Select the camera's aperture mode and set the aperture to the smallest setting. If you let the camera auto-

Top Left—Different types of perspective can be accomplished by using various lens focal lengths. In this image of an old landlocked fishing boat, a telephoto lens was used to shoot the boat from a distance. **Bottom Left**—Changing to a wide-angle perspective required that the photographer move very close to the boat. Notice that the perspective distortion has exaggerated the size of the tires on the front of the bow. **Above**—Perspective can be accomplished by shooting across a subject with a wide-angle lens. This usually requires the use of a higher ISO setting like ISO 400 to ensure that you can get the f/16 to f/22 settings necessary to maintain accurate focus.

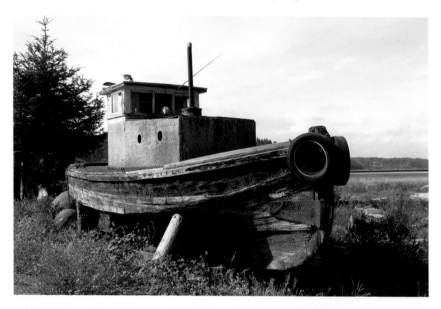

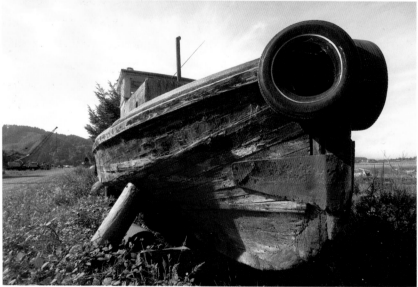

matically focus, it may select an area too far in the distance, causing the close object to be out of focus. Remember, this is due to the "⅓ in front to ⅔ behind" rule we discussed earlier.

Find a point just beyond the close object, center your camera on that point, and pre-focus by pressing the shutter down halfway. Once the focus point has been selected, move your camera back into the original framing position and depress the shutter. To be assured that you got the image, try several pre-focused points before you move on to the next shot. Remember that the LCD screen is small, and you cannot always determine an accurate focus. Since memory cards are becoming very large and inexpensive, time is your only expense in taking several exposures.

Portraits. Another depth of field application for digital photography is portraits. Generally, you will want the person sharp and the background out of focus, so depth of field is critical. Set your camera to aperture mode again, and select the widest aperture possible (smallest number). As you do, the camera will shift to a higher shutter speed to maintain an accurate exposure. This wide aperture will provide selective depth of field and reduce busy backgrounds to a soft blur, which will be less distracting.

You will then want to zoom the lens into the telephoto mode (the depth of field will decrease even further as the focal length increases). The telephoto function of the zoom lens is more flattering for portraits, as wide-angle lenses tend to distort and exaggerate facial features. If you find your subject is too large in the photo, just step back until the subject proportionately fits in the picture.

Many of the digital cameras today have a special portrait mode that automatically sets the shutter speed and aperture to the configuration mentioned. If your camera has this mode, then taking portraits just got even easier.

Special Situations. Most of us have encountered a situation where something that would make a great photo is just out of reach behind a chain-link fence. Well, you don't just have to shrug and walk away. You can actually shoot through the fence and use depth of field to your advantage.

First, position yourself as close to the fence as possible. Use the widest f/stop on your camera (smallest number) to expose your image. When you view the results, you will see that the fence has disappeared. Keep in mind that your photo will not be as sharp as it would be if the fence were not there, because the fence still exists and is blocking part of the image. If you were to step back a few feet and try the shot again, you would discover that the fence is now a visible out-of-focus blur in your photo.

An SLR zoom lens set to 300mm with the aperture set to f/6.3 forced the background out of focus so that good separation around the edges of the face was obtained. The ISO speed was set to 800 to ensure that a high shutter speed of 1/500 was obtained.

A 300mm telephoto lens set to f/6.3 allowed the photographer to keep the subject sharp and the background out of focus.

Left—Animals at the zoo are usually behind fences, so taking photos is difficult. Here, we took a photo a few feet from the fence, and even with a wide aperture, some detail in the fence was apparent. **Right**— In this image, we used the same aperture setting, but moved within a couple inches of the fence to take the picture. As the depth of field cannot carry detail from this close to the lens, the fence magically disappears. You may see a slight loss of quality when shooting through fences.

6. Shutter Speed Applications

We all learned in Photo 101 that motion in a photo is controlled by the shutter speed. In order to keep a moving subject sharp in the final image, you must use a high shutter speed. The higher the shutter speed, the better the action is stopped. You also need to use higher shutter speeds when you use long lenses on your camera. In addition, the higher shutter speeds also minimize any camera movement caused by a nervous or excited photographer. Let's address each of these issues separately.

The higher the shutter speed, the better the action is stopped.

● AVOIDING CAMERA MOVEMENT

One of the problems many photographers encounter when taking pictures is camera movement. Photographers who stand with their feet together, arms apart like a flapping bird, and quickly press down on the shutter may get some camera motion as the shutter is fired. The best way to avoid this is to steady yourself like a camera tripod. Although you only have two legs, spread your feet apart, and you will find it easier to maintain your balance. Place your elbows snug to the sides of your body to steady the camera, and then gently squeeze the shutter button.

To minimize camera movement, stand with your feet apart and arms pressed down tightly toward your body.

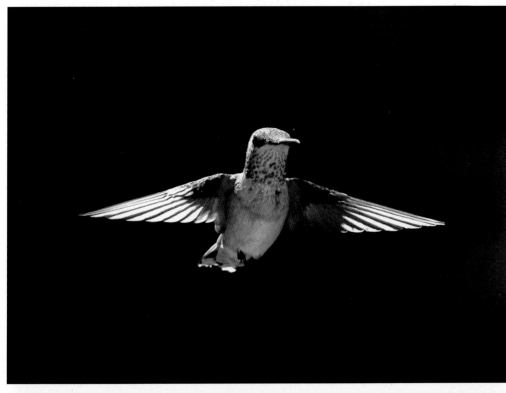

Top—A digital SLR camera, 300mm telephoto lens, and a $1/4000$-second shutter speed stopped the fast movement of the humming-bird's wings. **Bottom**—We used a 300mm telephoto at $1/4000$ second to capture this bird in flight. The camera was set to a pre-focused point at the bird feeder, so that as the bird started to land, a series of images was taken. This image was the best of the group.

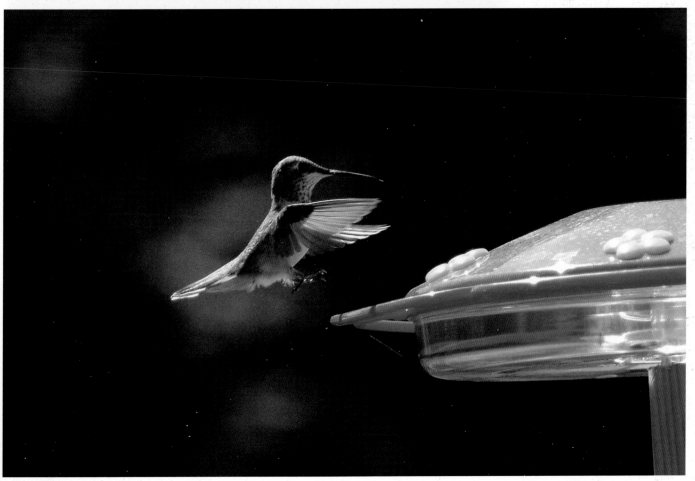

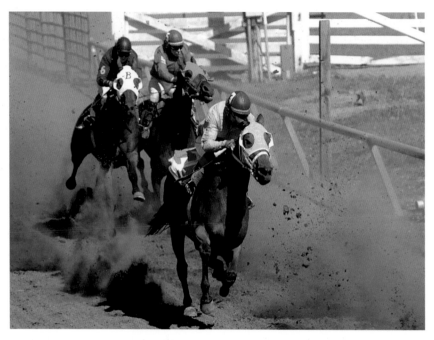

We used a digital SLR camera and a 300mm lens to capture the fast action of this horse race. A setting of ISO 1600 was used to maintain the high shutter speed of $\frac{1}{8000}$ second.

○ SHUTTER PRIORITY

On your digital camera, you can use the shutter priority mode to keep the shutter speeds as high as possible. This mode will allow you to select a given shutter speed, and the camera will automatically select the aperture necessary for a good exposure. If you have selected too high a shutter speed for the amount of light available, the camera will give you an error indication, but will allow you to keep on shooting anyway. Unless you select a slower shutter speed, this could yield some inaccurate exposures.

○ SPORTS MODE

Some of the newer digital cameras today have a sports exposure mode. This function automatically sets itself to the highest shutter speed possible to reduce the amount of motion in your image. Since it works hand in hand with the aperture to create a good exposure, the shutter speed will fluctuate as the lighting changes.

Some of the newer digital cameras today have a sports exposure mode.

○ MOTION STUDIES

Creating Motion. We just told you how to reduce the motion in your image, and now we're going to tell you how to create it. In an effort to balance the art and science of photography, you will find many creative photographic techniques for creating motion in your images. The problem is that there are so many ways to create motion with your digital camera that it's hard to find a starting point.

We have not talked much about the digital SLR with its interchangeable lenses, so let's start there. The process of creating zoom motion works the same on both film and digital SLRs, but is almost impossible on point & shoot cameras. The reason is that you need to be able to manually move the zoom lens during the exposure. The point & shoot cameras lock in on a specific point when shooting so that leaves them out of the game on this effect.

Zoom Motion. Here's how it works. Set your camera to a shutter speed that will allow you to zoom the lens smoothly through the entire zoom range and maintain an even exposure. If the light level is too bright, you may need neutral density or polarizing filters to reduce it. If you shoot early or late in the day you will be able to use the slower shutter speeds.

Select a subject that you want to enhance with motion and focus on that subject. As you press the shutter, smoothly zoom the lens through the entire range (the best results are accomplished if the camera is mounted on a tripod). You can also make the exposure long enough so that part of the image is made without zooming. This will provide more density and sharpness to the primary subject in the scene.

This technique is not an exact science, so it will take some trial and error. Film photographers have to shoot the setup over and over, and still may not get the shot. Digital SLR users, on the other hand, can preview the

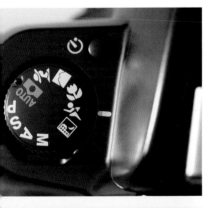

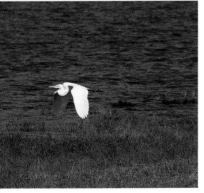

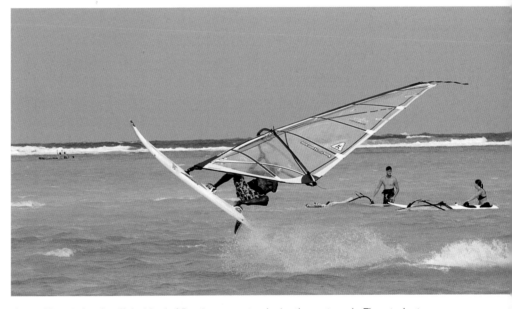

Above—This wind surfer off the island of Bonaire was captured using the sports mode. The actual setting selected by this mode was $^1/_{2000}$ second at f/6.3, with the ISO set to 400. **Top Left**—The sports exposure mode is usually represented by an icon of a runner. The sports mode is similar to the shutter mode, except that it will reduce the shutter speed when the light levels drop. **Bottom Left**—The camera was set to sports mode and we fired rapidly as the egret took off from its resting place. The camera was set to ISO 400, and the resulting exposure combination was $^1/_{2000}$ second at f/6.3.

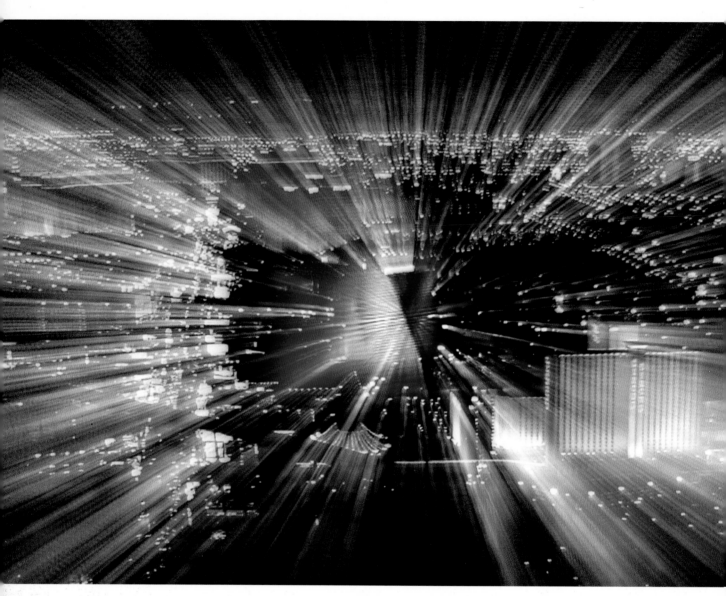

A camera was set up on a tripod at night in Las Vegas. Trial exposures were made until it was determined that a four-second exposure at f/22 would yield great results. The zoom lens was then moved from wide-angle to telephoto during the exposure to create a unique motion effect.

image immediately, make any necessary corrections, and then take an improved version of the photograph. It sure feels good to walk away with confidence, knowing that you got the photo.

Pan Action. When you follow a moving object in the viewfinder and move the camera throughout the exposure, you are said to be *panning* the subject. It is tricky to follow the action with a camera, and the results are difficult to predict. This is why the digital camera comes in handy. Best of all, you can use any level of digital cameras to perform the panning action using the same method.

Set your camera so that it will have a very slow shutter speed. This may require photographing in low light, using a small aperture, or even putting

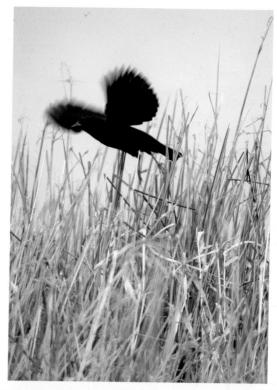

Right—When we stopped a telephoto lens down to f/22, it resulted in a $^1/_{30}$-second shutter speed. The shutter speed was high enough to stop the action of the body, but not high enough to stop the wing movement. **Below**—The camera was set to the lowest ISO setting (80) and the smallest aperture possible (f/16). The photographer panned the camera with the rider as she quickly pedaled down the road. The $^1/_{15}$-second shutter speed kept the rider reasonably sharp, but blurred the background.

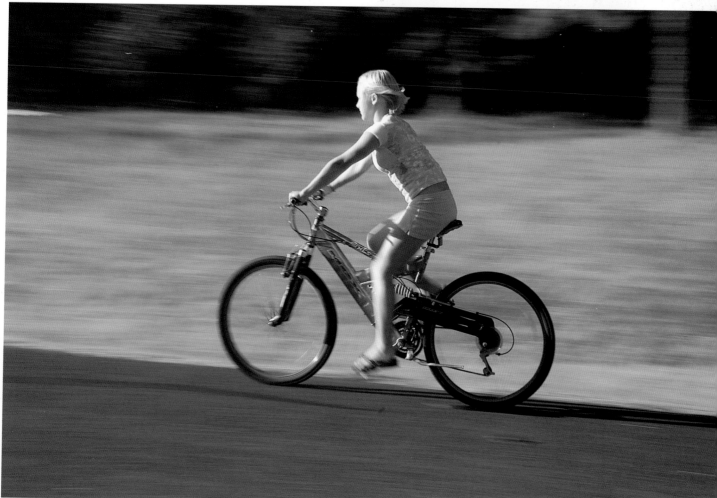

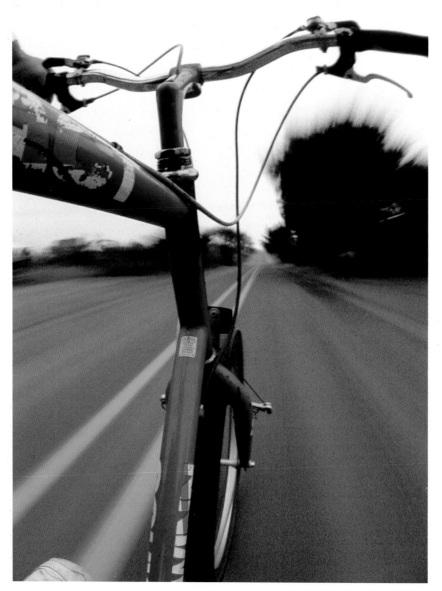

A small point & shoot camera was mounted to a bicycle and secured with a safety line. The camera was set to the smallest aperture and the lowest ISO rating (100). As dusk approached, the bicyclist pedaled down the street, pressing the shutter button at various times along the way.

Find a subject that will be moving past you, like a child riding a bicycle.

a neutral density filter on the lens. Find a subject that will be moving past you, like a child riding a bicycle.

Using the optical view-finder in the top of the camera, visually follow the bike and rider as they pass by you. Press the shutter while the camera is moving, keeping the bike rider centered in the frame. Check your results on the LCD viewer and adjust your shutter speed to achieve the effect you desire. The child on the bike should be reasonably sharp and the rest of the background will have a blurred motion that indicates the direction of the bike movement.

Avoid pressing the shutter as

you cross sidewalk cracks or

potholes.

If you are having trouble with exposure, you can use the exposure compensation menu to reduce or increase the exposure. If that fails, try the manual exposure mode. It may take several tries, but you can view each try on the LCD and make necessary corrections before the next shot. Once you have mastered the bicycle motion, you can move on to cars, horses, trains, planes, or anything else that moves across your viewfinder.

Take It for a Ride. Another fun motion application is to mount the camera itself on the handlebars of your bicycle with a clamp pod. There is some risk to the camera with this exercise, so you should attach a safety line to the camera just in case. This is also no time to show off while riding the bike, for if you crash and burn, so will your camera.

Once the camera is secure, press the zoom control until the lens is at the widest position. Set the camera to the aperture exposure mode with the lens at the smallest aperture. If the resulting shutter speed is not below ¼ second, you may have to use neutral density filters to drop the exposure even more. You can also shoot early or late in the day to reduce the exposure level and achieve slow shutter speeds.

When you are sure everything is set, pedal away, pressing the shutter as you go. Avoid pressing the shutter as you cross sidewalk cracks or potholes, as they will blur your final results. If you have done everything right, the final image will have the bike spokes blurred, the front of the bike sharp, and objects on either side of you blurred, indicating motion.

O MOTION AT NIGHT

If you have a sturdy tripod, you can create some long-exposure motion studies at night. Photos of carnival rides and cars on freeways can provide some great images with streaked lights. All it takes are a few minor adjustments to the exposure system on your camera.

Most digital cameras have at least an eight-second time on the shutter speed dial. Start by setting your camera to manual exposure at a two-second shutter speed with the f/stop somewhere in the middle of the scale. Don't forget to use your tripod. Run a test exposure and check the playback to see what adjustments need to be made to the exposure.

Also check the color balance to see if the auto white balance is working with the night lighting. If the color is off, you may have to run a test using the tungsten or fluorescent settings to see if they provide better results.

O MOVING SUBJECTS

We have one final motion technique to show you, but it goes against most of the technical rules for creating good photographic images. The process is very simple, yet the results are very unpredictable.

The camera was held firmly at $\frac{1}{15}$-second shutter speed. Subjects close to the camera were blurred more than those in the background because their close proximity causes them to move faster across the image plane.

Set your camera so that you have a very slow shutter speed by using a small aperture, neutral density filters, low light levels, or a combination of all three. Then find yourself a moving subject. Since we live at the coast, one of our favorites is the trusty seagull. These fellows are graceful fliers, and you can be assured that if you provide food, they will come.

As the gull is flying by or hovering for a handout, depress the shutter. Most everything in the image will be blurred, including the gull's wings. In most cases, the final image will not be very sharp, but it sure provides an artistic form of photography.

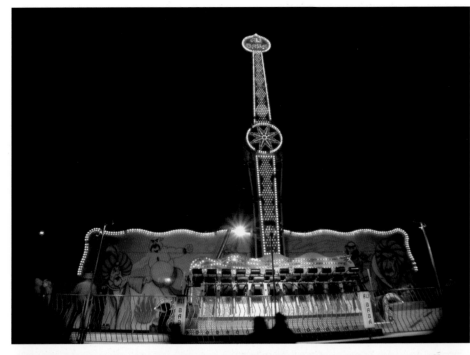

Top—The camera was mounted to a tripod positioned in front of a carnival ride. Several exposures were made, varying in duration from one to four seconds, to determine the best exposure at the smallest aperture. This exposure was made when the ride was stopped. **Bottom**—A second image was made when the ride was in full motion. The camera was manually focused so that there was little shutter delay.

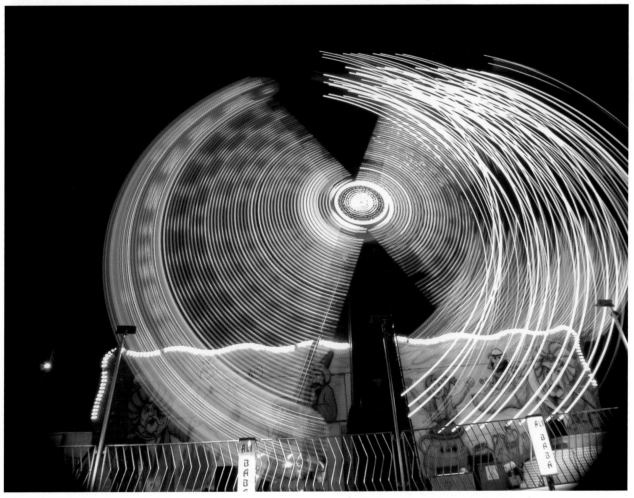

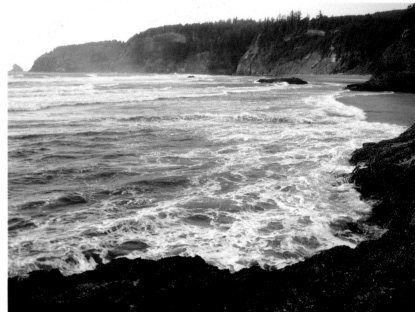

Right—The camera was set up on a tripod just after the sun had set. The first exposure was made with a wide aperture to achieve the fastest shutter speed possible. In this case the exposure was $\frac{1}{15}$ second at f/2.8. **Below**—This exposure was made using the smallest aperture (f/22), so the resulting shutter speed was a four-second exposure. Notice how the waves are now very blurred and misty looking.

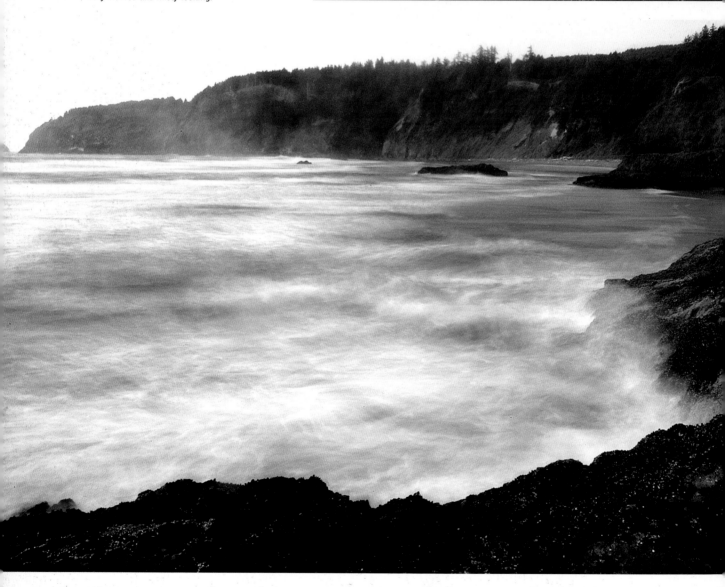

7. Flash Tips

There are advantages and disadvantages to having the flash built into the camera.

Ever since the electronic flash was invented by Dr. Harold Edgerton, photography has never been the same. These tiny little packages filled with inert gas can produce enormous bursts of light in a fraction of a second. Just about every point & shoot camera made today sports one of these built-in electronic flashes.

There are advantages and disadvantages to having the flash built into the camera. The upside is that you don't have to carry an extra flash, there are no cords, and the flash is fully integrated with your camera system. The downside is that direct flash lighting is harsh, may cause red-eye, and causes reflections from shiny surfaces.

● WHAT THOSE ICONS MEAN

Most digital cameras will have various lightning bolt icons that represent the status of the flash. The icon for no flash is a lightning bolt with a line through it; auto flash is simply the word *auto* with a lightning bolt icon; red-eye reduction is symbolized by an eye; and flash-always-on or flash fill is represented by just a lightning bolt. The one you select will be determined by the lighting condition you have for your photo session.

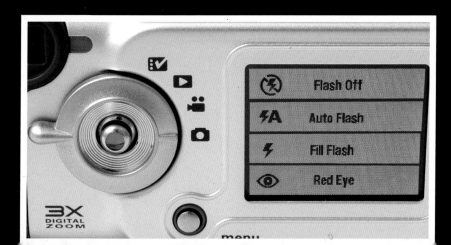

The location of the flash icons varies from digital camera to camera, but most use the same symbols to represent the various functions.

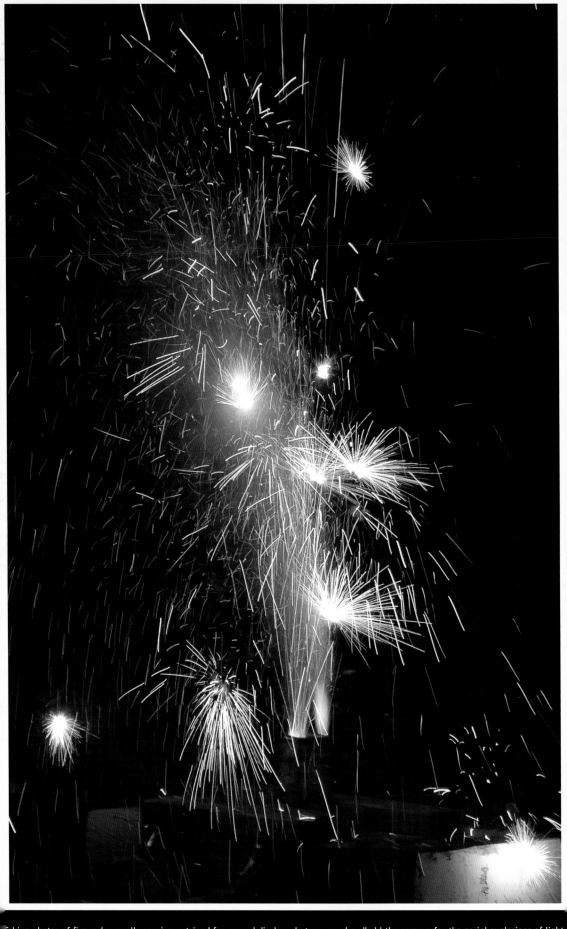

Taking photos of fireworks usually requires a tripod for ground displays, but you can handhold the camera for the aerial explosions of light. Be sure you turn off the flash, or the subjects in the foreground will be overexposed and you will lose the impact of the fireworks.

Left—A digital SLR camera was set to ISO 1600 and the telephoto lens set to wide open to allow an exposure of ¹/₁₂₅ second at f/5.6. **Above**—Generally, flash photography is not acceptable during concert performances, so you should turn the flash off. For this low-light shot, the camera was placed on the back of a chair and firmly held while making the final exposure of ¹/₁₅ second at f/4.

○ NO FLASH

You would use this mode when you don't want the flash to come on under any circumstances. There are occasions where it is unacceptable for flash to be used; when photographing wedding ceremonies, plays, concerts, football games, and firework displays, the flash should be disabled.

Without the aid of a flash, much of your lighting will be from light sources other than sunlight. You may want to switch the white balance from auto to the predominant source that is lighting your scene. Just remember to set it back to auto white balance when you are done.

○ AUTO FLASH

The auto flash setting is generally the default setting for the flash. This setting allows the camera to be the judge as to when and when not to activate the flash. As the light level drops, the flash will automatically fire if necessary to achieve a good exposure.

The auto flash determined that auxiliary lighting was necessary because of the deep shade, so the flash turned on as the shutter was depressed and captured that very special smile.

Left—This photo is a good example of the red-eye that occurs when taking flash pictures of people in a dark room. Right—When we used the red-eye reduction, the camera fired a series of flashes before the final picture was taken. Although the red-eye problem was not completely eliminated, it was reduced enough that the image is now acceptable.

Left—When you bounce light off the ceiling, there are no harsh shadows and the lighting is softer. Right—Notice the heavy shadows on the wall caused by direct flash lighting.

○ RED-EYE REDUCTION

Generally, you are in a darkened area when taking pictures of people with the internal flash. In the dark, the human eye opens the retina up, improving vision. When the flash fires, the light passes through the retina and reflects on the back of the eye, causing the red-eye effect. To minimize this, set the flash mode button to red-eye reduction, and it will fire out a burst of small flashes, forcing the retina to close down before the image is taken.

This mode isn't always successful, as some people's eyes are unchanged by the red-eye reduction mode. Red-eye can also be reduced with the use of an external flash, as discussed later in this chapter. The red-eye effect can also be removed using photo editing software.

FLASH FILL

The flash fill icon should be selected when you are taking pictures of people with their backs to the sun. The harsh sunlight causes dark shadows and extreme scene contrast range.

When you select the flash fill setting, the camera will meter for the sunlight exposure, but will also fill the shadows with the proper amount of flash. Because you are working in bright sunlight, you are able to use a shutter speed that is adequate to stop most any action.

If you use the flash fill setting in low light, the flash will fire but the shutter speed for the background image will be too slow. The result is a ghost image where the main subject will be sharp because of the flash fill, but the surrounding area will be blurred, causing it to look ghost-like.

You can create a great sidelighting effect if you hold an external flash with sync cord at a 45-degree angle from the subject.

Right—When the sunlight is behind the people you are photographing, it can cause harsh lighting and deep shadows. This is a problem, because if you try to expose for the faces, you will overexpose the background. **Above**—The solution is to use the flash-fill setting. It forces the camera to fire the flash in sunlight, which adds light to the deep shadows, providing a balanced exposure.

EXTERNAL FLASH

That's enough information about the internal flash for now. By adding an external flash unit, you can create some unique lighting with your digital camera. If your camera has a hot shoe on the top, you can attach a dedicated flash unit. Some of these flashes have rotating heads that can be turned

Left—Typical flash image taken with a point & shoot camera's internal flash. The lighting is very flat and provides very little depth to the scene. **Right**— When we add an external flash to the point & shoot camera via a sync cord, we can vary the lighting by moving the flash. By holding the flash above the mushrooms, the toplighting creates a feeling of increased depth to the scene.

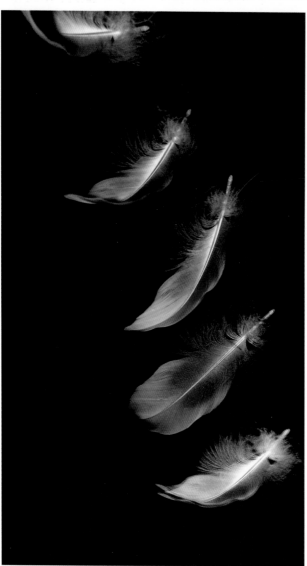 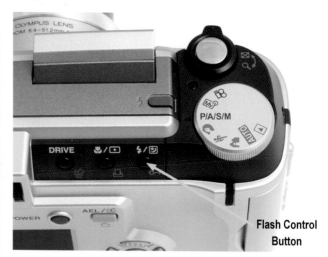

Flash Control Button

Left—If you use one of the more advanced external flash units, you can take advantage of the stroboscopic setting to create some unique images. We mounted the camera in front of a black background and a feather was dropped from above. The motion of the feather falling was captured with a manual shutter speed of two seconds and the flash firing at four flashes a second. **Right**—The flash button on most point & shoot cameras is represented by a lightning bolt icon. By pressing this button, you can access the various flash controls in either the LCD menu on top of the camera or the main LCD menu on the back of the camera.

to provide bounce flash off the ceiling or walls. Other flash units may have a built-in bounce card to provide nice soft lighting.

You can add auxiliary lighting to the side and top of your subjects by using a sync cord attached to the hot shoe or external flash connecter. With this connection, you can use both the internal and external flash to create ratio lighting.

○ SLAVE FLASH

One of the latest developments in the flash world is the auto DX (digital) cordless slave flash. When you fire the camera, the internal flash and the cordless flash will fire at the same time and both cut off simultaneously. If you see that the combination provides a little overexposure, just use the flash exposure compensation menu to cut down the exposure.

Best of all, you can hold the camera in one hand, the slave in the other and achieve creative lighting in seconds. After each shot you can look at the lighting ratio and pattern on the LCD preview, and make a modification before taking the next shot.

The internal flash and the cordless flash will fire at the same time . . .

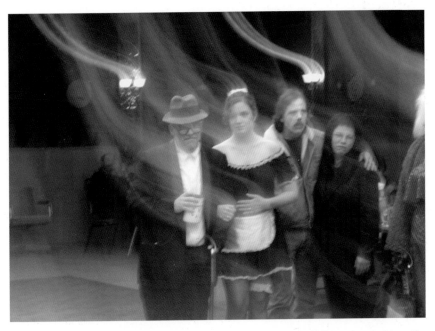

Some cameras have the ability to shoot in a slow-speed flash mode. In this Halloween party picture, the camera was set to this mode so that the flash fired during a one-second exposure. The combination of the sharp flash exposure and the available light movement provides the ghosting effect.

8. Lighting Conditions

One of the biggest differences between film and digital is the way they handle sunlight. Color negative film is very forgiving with its wide exposure range. It allows you to shoot directly into the sun and still achieve a full detail range from the highlights to shadows. Color slide film offers a narrower exposure range, but handles direct-sun shooting just as well.

The digital camera can help you capture photos in all types of lighting conditions.

Digital cameras can't take pictures directly into the sun at all.

● INTO THE SUN

On the other hand, digital cameras can't take pictures directly into the sun at all. You can have the sun in the picture as long as you use a wide-angle lens so the sun is very small and not a critical part of the image. If you try to zoom in and include the sun in your image, you will find that the area around the sun will not have any detail. The digital camera CCD cannot record exposure levels that high and still retain detail in the mid-tones. By the time you reduce the exposure so the sun records properly, it is the only object in the scene with any visible exposure.

Left—This unusual tree was photographed using the normal exposure system of the camera. The bright light to the right of the tree forced the camera to underexpose the image. **Right**—To compensate for this problem, the camera was pointed to the left and the exposure lock button was depressed. The camera was then repositioned before a new exposure was taken.

Left—The bright sun peeking through the flowers forced the camera to expose for the sun and sky, resulting in an underexposure of the flowers in the foreground. **Right**—The camera's internal flash was set to always on, and the exposure lock button was depressed on an area where the sun was not visible. Just before the shutter was depressed, the camera was moved back into position so the sun was in the picture.

Until someone invents a chip that can record both the sun and mid-tone detail with a digital camera, we have to devise special shooting techniques to make it work. These tricks will allow us to capture the sun and still maintain an acceptable exposure in the remaining image.

Early morning dewdrops on a blade of grass were captured with a 105mm macro lens on a digital SLR camera. A two-stop neutral density filter and a red filter were added to the front of the lens, which was set to f/2.8. Manual focus on the dewdrops forced the sun in the background to be completely out of focus and very large.

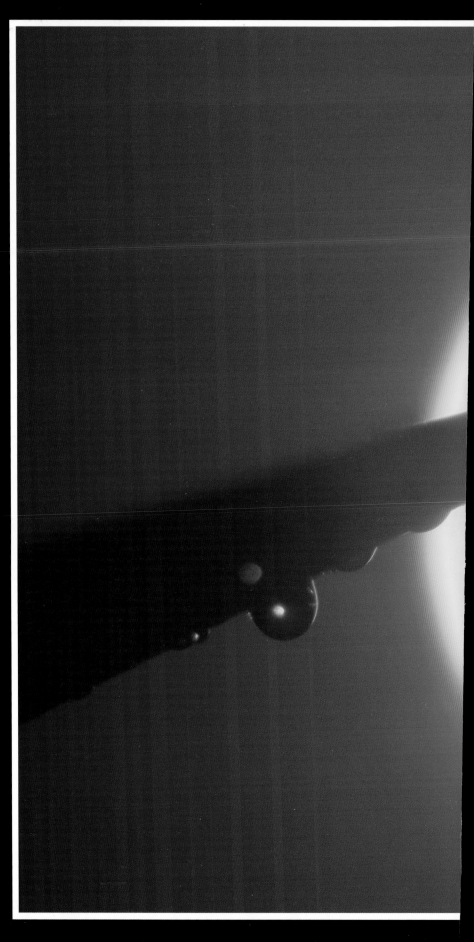

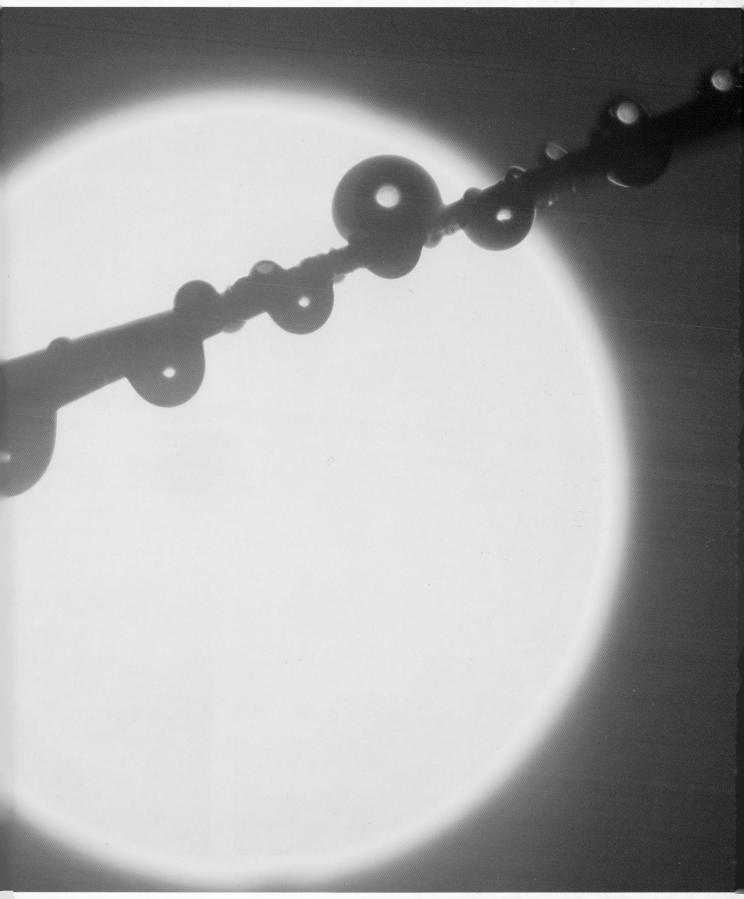

O OVERCAST DAYS

The first step is to discard the old instilled belief that the best photos are taken in full sunlight. You now need an overcast day where the lighting is bright, but the sun is blocked with clouds. Your images will be rich in color, and you will rarely need to use flash fill to balance the lighting. The auto white balance feature found in digital cameras also allows you the freedom to move into shade or deep shade, and still achieve excellent color quality. After shooting digital cameras for many years now, we find that they love this type of lighting and in fact work better in low light levels than high-speed film cameras.

Left—Early morning fog rolled in and partially covered the trees along the beach. The bright sun was positioned so it was partially blocked by a tree and the exposure lock was used to ensure a correct exposure. **Below**—This casual portrait was taken on a heavily overcast day, so there were no harsh shadows. The portrait mode was used to ensure that the background was out of focus, and the subject remained sharp.

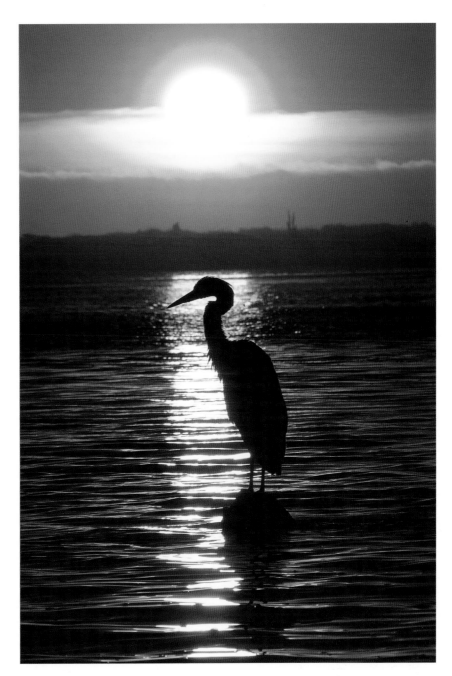

The 75–300mm zoom lens allowed a heron fishing in the lake to be silhouetted by the setting sun. The camera was set to f/6.3 in the aperture mode, which kept the subject sharp and the remainder of the image slightly out of focus.

○ SILHOUETTES

Now let's address the problem you encounter when using digital to shoot into the sun in the normal or telephoto mode. Since both of these modes make the sun appear larger, an unobstructed view of the sun will force the camera metering system to make a drastic underexposure, which results in a complete loss of midrange detail. We find that it works best to place an object in the direct path of the sun to form a silhouette. This partially blocks the sun's image, thus maintaining the midrange detail. Silhouettes can be taken at any time of the day, as long as the sun is shining. They do require a little extra care in framing and exposure to get some good results.

Opposite—Silhouettes can be taken at most any time of the day, and this was taken at midday. The exposure lock was used and then the camera repositioned so that only a small piece of the sun peeked out from behind the tree.

If you have an SLR digital camera, it will be easier to accurately place the sun in position behind a person, tree, bush, branch, or flower. The SLR also has an accurate camera meter for determining a correct exposure. If you get a poor exposure, use the exposure compensation dial to correct the problem. When there is a specific area where you want detail, you should center the camera on that area, press the exposure lock button, and then pan back to shoot your final image.

If you are using a point & shoot camera for the silhouette, you should use the LCD viewer to line up the sun behind the subject. Using the optical viewfinder on the top will move the alignment of the sun and object slightly out-of-phase, which may bring the sun into full view. When in doubt, check each exposed image using the playback function on the LCD viewer.

Add a Flash. Using flash fill on silhouettes will require some experimentation with the flash exposure compensation menu on the camera. In most cases the flash will be too strong, so you will have to reduce the exposure using this menu.

SUNRISE, SUNSET

Probably the easiest types of pictures to shoot are those taken with the sun low on the horizon, or when it hides behind other subjects. When the sun is up high and directly in the picture, the exposure meter will force the camera to underexpose the image. When the sun is close to the horizon, the exposure meter in the camera becomes very accurate.

If you find yourself in front of a really nice sunrise or sunset, allow the camera to make the first decision on exposure. Then use the exposure com-

Left—The same lake scene was photographed in the early morning when the lake was shrouded in fog. The resulting image was very low in contrast, with gray highlights and lacking blacks in the shadows.
Right—This lake scene was photographed a few minutes after sunset, so there was very little detail in the shadows and the contrast level was high.

Top—When the setting sun is partially blocked by clouds, you can generally use the exposure indicated by the camera. In this case, we used a 500mm mirror lens on a digital SLR camera to capture a dramatic sunset at $1/500$ second at f/8. **Bottom**—We took this picture from a high angle so that a reflection of the sunset could be seen in the sand. Bracketed exposures of the scene were made, and the best was the $+1/3$ overexposure.

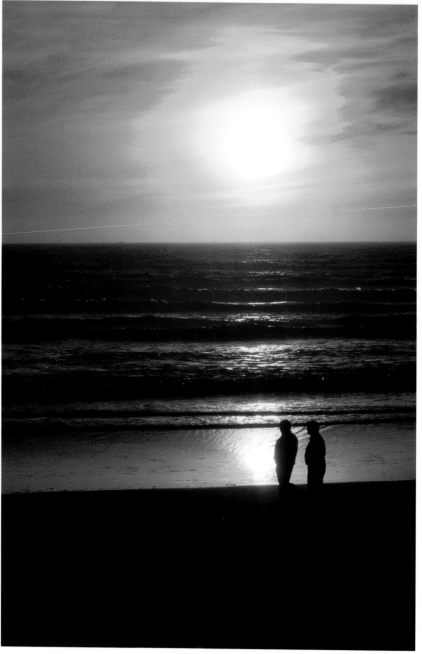

pensation to increase and decrease the exposure. You will probably find all the bracketed exposures acceptable, but each image will have a different feel.

Remember to place the sun in a ⅓ position for better composition. Too many sunsets are taken with the sun dead center, much like a bull's-eye. For some more tricks for good composition, don't miss chapter 10.

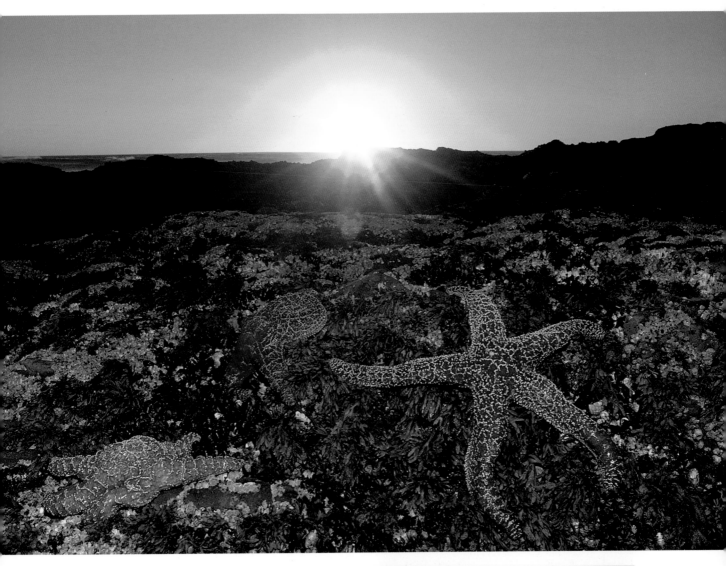

Right—This late afternoon sunset produced a very high contrast scene, providing almost no shadow detail. **Above**—The addition of an external flash set to manual exposure was used to create a balance between the sunset and the starfish. We adjusted the variable flash power until the right combination was previewed on the LCD viewer.

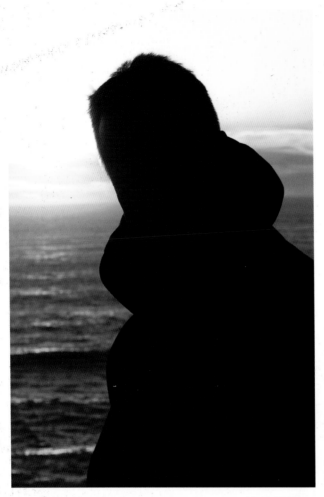

Add a Flash. If you want to take a picture of someone at sunset, you can use the flash fill system on your camera. This fills in the missing light on their face when they look at the camera with their back toward the sunset. You will have to experiment with the flash exposure compensation menu to get the right balance between the sunset and the flash exposure. In most cases, you will want to compensate toward underexposure with the flash fill.

Left—A portrait taken at sunset can produce very harsh lighting with no facial detail. If you increase the exposure to compensate for the missing detail, the sky will become pure white. **Right**—The internal flash was turned on, which forced the flash to work even when the camera's auto system wouldn't. The flash compensation control was used to obtain the best balance of sunlight and flash.

9. Point of View

Most film photographers will shoot one or two pictures of a scene and then move on to the next shot. This is usually due to the growing concern about the cost of film, processing, and printing. Other times, it is because the photographer loses interest in the subject matter.

● NEW METHODS OF PHOTOGRAPHY WITH DIGITAL

Thankfully, shooting digitally eases the concerns over film cost, allowing the photographer greater freedom in shooting a larger number of images. Memory cards are less expensive than film and are gaining greater capacity. You can now take plenty of photos and use the cards over and over again. The cost of the cards is equivalent to a few rolls of film, so once you get past the initial investment, the expense of taking images is nonexistent. You can delete images as you shoot, or later as you view them on your computer. This way, you only keep those images that meet your quality standards.

When you have a selection of images you want to print, you can now print them on your inkjet printer in the privacy of your own home. Not many had the luxury of being able to do that with film.

If you prefer, you can take your images to your local photo processor and they can make prints for you. All you do is copy any images you want printed back onto a memory card via a reader and take them to a photo kiosk. You save even more as you can print selected images, not every one that you take.

● POINT OF VIEW

Now that you have your digital camera and a couple of memory cards, let's go take some pictures! You can improve the quality of your images by using a technique called *point of view*. This adds variety to your photos and will spark your interest in taking more images.

The human mind definitely has preferences when it comes to viewing photographs, so the key is photographing something to interest everyone. By varying your point of view, you will use a variety of photographic skills that will result in images to please each and every viewer. Through the use

Memory cards are less expensive than film and are gaining greater capacity.

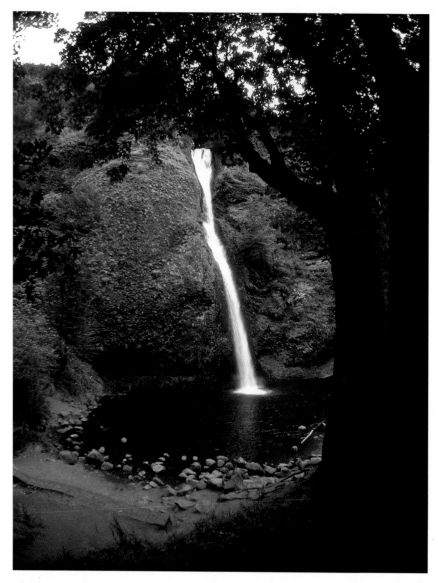

This wide-angle view is enhanced by using the silhouette of the tree as a frame to add depth to the photo.

of perspective, variety in lens focal lengths, subject framing, and a sprinkling of other creative ideas, your images will quickly take on new levels of quality.

Let's take an example and see just how applying a different point of view will make a difference. Quite often people taking landscapes will just get out of their car, raise their camera, take the shot, and move on. They may have documented the scene correctly, but the resulting image is usually flat in image content, and has no depth.

PERSPECTIVE

When you step out of your car to snap that image, you may find that most of the objects in the scene are proportional to each other, and seem to be on a single focus plane. In this case, what the image really needs is some depth, or perspective. This generally means that you will have to turn off the car engine and spend a little more time taking the picture.

Here's a helpful exercise: Take a picture of the scene exactly the way you normally would, then stop and look around. Do you see a small branch, overhanging tree, a wall, or even the side of a building nearby? The key is to find something that adds to the flavor of the image. Set the zoom lens to a wide-angle setting, and position yourself so that the close object is near the edge of your photo. This may mean that you will have to change your shooting position in order to get both the object and initial scene in the frame.

Switch your camera to the aperture mode, and set the aperture to the smallest opening (which is the largest f/stop number on your camera). Point your camera at an area just beyond the object in the foreground and push down the shutter halfway to lock the focus. Then re-frame the shot and continue pressing down on the shutter until the picture is taken. Move around and try several different positions with the object in the foreground. Then look around for other objects that might help add perspective to the scene.

The exaggerated perspective creates the illusion that the airplane's wing is larger than the building, which just happens to be the world's largest wooden structure.

Left—A wide-angle lens, used in available light, provides the viewer with the feeling of being there.
Right—By adding a flash, you can now snap a close-up of the gondolier as he passes by.

○ LONG, MEDIUM, AND CLOSE-UP

Another simple way to improve the quality of your photography is by varying the view of the subject matter—from full-form to a smaller section and everything in between. You can use a zoom lens, like they do in Hollywood movies, to create a long, medium, and close-up view. Since most point & shoot digital cameras have zoom lenses, it is a simple process of trying several images with the lens set to wide, normal, and telephoto. You can also change your shooting position when using different focal lengths to add variety to your images.

Left—Sometimes a photo lends itself to the horizontal format—especially when photographing a panoramic view. **Right**—By switching to the vertical format, you can provide a different perspective to your photo.

○ HORIZONTAL OR VERTICAL

Another simple trick, varying your image format, is often used by magazine photographers. Many learned early on in their careers that whenever they had a great shot, they should always shoot a vertical version just in case their editor decided it was cover material.

Consider the option of taking a vertical image in addition to a horizontal view.

However, most other photographers simply tend to take horizontal images. You need to consider the option of taking a vertical image in addition to a horizontal view. There are many times a subject naturally lends itself to a vertical view—tall buildings are a great example. Taking images on digital memory cards is inexpensive, so you should never have to say, "I wish I'd shot a vertical, it would have looked so much better." Just do it.

○ LCD VIEWERS ADD NEW PERSPECTIVE

The LCD viewer has presented digital camera shooters with one of the most versatile and creative tools possible. You are no longer restricted to an eye-level view of the world. Many of the more recent digital cameras even have viewers that swing out and can rotate more than 180 degrees. This allows you to hold the camera at any angle above or below the subject to create some very unusual points of view.

This even gives a new perspective to self-portraits. First, you zoom the lens to the wide-angle position. Then you rotate the viewer backward, compose the picture, and take the shot.

The LCD viewer is especially helpful when doing close-up nature photos. You can get that super low-angle shot and not get dirty by laying on the

Above—The photographer has the LCD viewer rotated 180 degrees, and she can see the barn swallows in the nest and properly frame the photo. **Left**—The camera lens was set to close-up, and the internal flash was used to expose the hungry mouths, waiting to be fed.

ground. Merely set the camera near the ground and rotate the viewer so that you can view it from above. Pretty neat, huh?

The LCD can also allow you to take pictures from positions not possible before. We found a barn swallow nest up under the roofline of the neighbor's house. It was only about twelve inches from the nest to the underside of the roof, so taking a picture or even seeing the contents of the nest was physically impossible.

We waited until the adult bird left to gather food, and carefully put a ladder against an adjacent wall. We then held a digital camera above and to the side of the nest with the LCD viewer pointed downward. Wow. The nest was full of babies! We then set the camera to macro mode (flower symbol) and set the flash mode to always on rather than auto. Now we were able to see and photograph the contents of the nest without disturbing the wee ones. A few shots later, we made a hasty retreat as the adult returned with more food for our hungry avian models.

When you rotate the LCD 180 degrees and hold the camera out at arm's length, you put yourself in the photo, creating a self-portrait. With the rotated viewer, you can easily compose the photo before you take it.

10. Composition

The art of placing objects in a scene so that they are pleasing to the eye is called *composition*. There have been a great many books and articles written on the subject, all featuring different ideas—but most agree on the basic concepts. Once you learn the basics of photo composition, it is just a matter of training your eye to identify it.

The art of placing objects so that they are pleasing to the eye is called composition.

Composition is the effective arrangement of elements to provide a pleasing visual flow in a photo. The simple lines here lead you up the stairs and provide perspective, as the stairs appear to become progressively smaller as you climb.

Left—In the excitement of finding a pregnant squirrel at the feeding station, little attention was paid to the busy background. **Center**—By changing the camera angle and zooming in, the background clutter is removed. A flash was added to provide more color to the front of the squirrel. **Right**—When we zoomed in further, we eliminated the corn and the bright sky area.

An effective arrangement of subject matter can convey an idea, tell a story, attract the eye through impact, create emotion, or capture a moment in time. The digital camera makes the art of creating well-composed images easier since you can see the results of your efforts immediately.

When we lecture on this subject, we break the subject down into two basic groups—undesirable and desirable. We like to start with the unsuitable forms as this helps photographers quickly identify their errors and allows them to correct them.

One of the most common culprits in a poor composition is a busy background.

○ UNDESIRABLE COMPOSITION

Busy Backgrounds. One of the most common culprits in a poor composition is a busy background. In the excitement of taking a digital image, the photographer doesn't always take the time to check the background. Thus you will often see photos of people with things growing out of their heads or bodies, and other objects that visually distract the viewer's attention from the subject. Most seasoned photographers learn to look at the background and mentally trace around the subject to see if it is growing extraneous objects, or is lost in a background jungle.

So, what do you do if you have been diagnosed with a case of cluttered background? The easiest way to solve the problem is to change your angle of view. Move a few feet to the side or move in to better isolate your subject. If that doesn't work, change the focal length of your lens and zoom in

on the subject until most of the background is gone. Another solution is to use a wide-open aperture with the lens in the telephoto position to force the background out of focus.

Light Trap. A light trap occurs when a very bright object becomes more dominant in the frame than your photo subject. Using a shallow depth of field will not improve the composition in this case, as the light object will still dominate the scene. The only solution is to change your angle by moving up, down, or to the side to eliminate the light object from the photo. If there is no way to remove the light area, you may be forced to remove it later using your photo editing software.

Left—In the excitement of the moment, photographers forget to check horizons and look for distracting objects in the scene. **Right**—Make sure the horizon is straight, and check for any light objects in the scene. This may require moving the camera angle or using your image editing software to crop the photo later.

Objects Too Close to the Edge. When you see a photograph with an object sitting near the edge, it usually means that the image was cropped too close to the subject. You need to give your subject room to breathe. The solution again is very simple—move. Physically back up so that you have more space around your subject. If you don't want to move, then you will need to zoom your lens to attain a wider angle in order to achieve the needed space.

Keep in mind when taking pictures of people that if you need to crop so that only part of the individual is showing, be very selective. Try to crop your picture so that it ends in the middle of the arm or leg. It makes the viewer uncomfortable to see a picture where the crop is at the joints.

Crooked Horizons. The digital camera has increased the chances of obtaining a crooked horizon, because it is harder to level the image in the LCD viewer. It is even difficult to level the image using the optical viewer as many digital cameras tend to slightly tilt to the left or right. The only cure is to be aware that there might be a problem, and make an extreme effort to keep the horizon level. Not to worry if you do end up with a crooked horizon, as you can easily correct it with your photo editing software by using the rotate function.

Not Enough Space. Too many times we have seen photos of someone with no space in front of their nose and plenty of space behind their head.

Physically back up so that you have more space around your subject.

Left—Both people and animals need space in front of their faces or, in this case, beaks. **Right**—Placing space in front of your subject may require that you change your zoom range or even take a step backward to acquire the necessary space.

Left—In an endeavor to get as close as possible with a zoom lens, the photographer put the windsurfer too close to the edge of the photo. **Right**—The solution was to put some space around the subject.

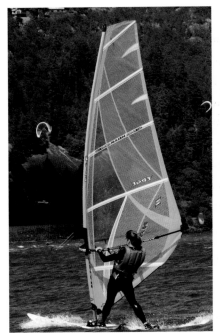 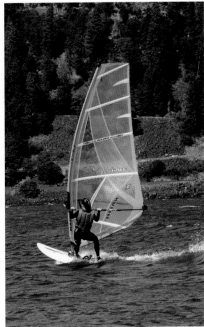

If a subject is looking or pointed in a specific direction, then you need to allow extra space on that side of the photo. This is especially true if you have captured a subject showing motion. You need to make sure the viewer feels like the subject has somewhere to go before reaching the edge of your photo. The solution is simply a matter of framing, which can be done by taking a bit more time for critical composition.

Too Busy. New photographers often try to put as many elements as possible in one picture. When you have too many unrelated subjects in one photo, the visual flow tends to get lost in the image. Your mind isn't sure on which subject your eyes should concentrate.

Now that you have larger storage space with memory cards, you can zoom in and single out individual subjects. Take a photo of each one, even if you take an overall image to document the scene. Often you will find that the combination of both types of photos will convey a better story.

○ DESIRABLE COMPOSITION

Rule of Thirds. One of the most common forms of composition is defined as the rule of thirds. While you look through the viewfinder, draw four equidistant imaginary lines through a scene—two horizontally and two vertically. This divides the image area into nine even segments with four points of intersection. It is at one of these intersections that you should place your main subject when you frame your image. This concept can be used for both vertical and horizontal images.

To see how well this theory works, take a few images with your subject placed in each of the intersecting positions. Then try composing an image

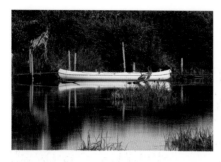

Left—When you place a subject in the center position, your eye goes directly to the subject and remains there. To have effective flow in a photo, your eye needs to move into and across the photo, then exit the photo or circle around and start again. Right—The composition of this scene was improved by zooming back the camera lens, and placing the canoe in the one-third position.

with the subject dead center in the bull's-eye position. You will quickly see the advantage of the rule of thirds.

Lines Leading to a Point. Lines leading to a point create very strong compositional form. Fence rows, railroad tracks, roads, sidewalks, and hiking trails can all lead the eye through the photo. If you want to make the composition even stronger, place a subject at the end of the line. You will find that this will hold the attention of the viewer even longer.

The lines of the fence posts lead your eye to a point, and the effect is enhanced because the shadows lead to the same point.

An unusual point of view was created using the 180-degree angle fisheye accessory lens on a digital point & shoot camera.

Patterns. Patterns are commonly-found treats from Mother Nature. You can also find interesting patterns amongst man-made objects. Best of all, there are a variety of methods for capturing patterns that can provide creative photos.

With patterns, you can take a photo from straight on and have great composition due to the inherent intricacy. If you add a small subject in the $^1/_3$ position, the image takes on a whole new look. You can add perspective by viewing the pattern from the side and capturing it with the wide-angle function of your zoom lens. If you switch to the macro mode, you can zero in on just a small section and isolate it for a new effect.

When you find a nice pattern, try plenty of photos. Play with the angles, adjust the lighting, and vary the subject placement before moving on to the

Left—The pattern of the paddles is enhanced as you are led to the yellow tape wrapped around one of the paddles. **Below**—Reflections can make a pleasing pattern composition.

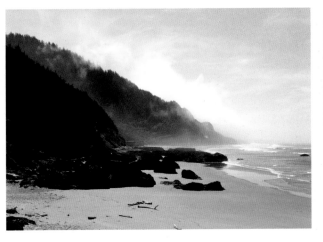

Left—This beach scene with the fog rolling over the mountains makes an interesting landscape, but it still lacks depth. **Right**—By stepping back a couple of feet and using a wide-angle lens, the fence frames the landscape, adding perspective.

next scene. More often than not, you will see that your pictures improve with experimentation.

Letter Shapes. Various compositional forms take the shape of a letter of the alphabet. The letter shapes we use most often are L, M, N, O, S, V, W, and Z. With your subject matter in one of these patterns, the compositional lines will either lead you through the image, or serve as a frame that provides depth. The letter *S* might be a winding road through the countryside, while an upside-down *L* could be a tree at the side of an image that creates a dark frame.

Looking up through the lighthouse staircase, we find a spiral composition that has a secondary line leading to a point formed by the lights.

11. Close-up Photography

Photographic terminology can often be confusing, especially when talking about taking pictures up close. Two terms show up in most photographic instruction manuals: *close-up* and *macro*. No matter which term is used, reference is being made to the photography of small subjects like flowers, insects, jewelry, or stamps. At one time, close-up images were of objects about the size of a breadbox, and macro photos were pictures of subjects the size of a postage stamp.

Today, as the new digital cameras allow you to move closer to small objects, the two terms become interchangeable. It doesn't matter which term your camera manufacturer uses, it just means that your camera has the ability to capture very small objects. Although SLR cameras have always offered the luxury of TTL viewing, it is now possible with the point & shoot digital cameras with the introduction of the LCD viewer.

● APERTURE OR CLOSE-UP MODE

As camera and lens come closer and closer to an object, the depth of field (focus in front of and behind the object) decreases. It gets more difficult to maintain sharpness with the increased magnification. In order to keep the subject sharp, you should set your camera to the aperture exposure mode. This allows you to select any aperture you choose. Most likely, the aperture you select will be the smallest opening (largest number) in order to maintain the maximum depth of field possible with your lens. The camera will then adjust the shutter speed to allow a good exposure using the aperture you selected.

If your camera has a close-up exposure mode, you can use it to force the camera to automatically set the correct aperture and shutter speed for you. In this case, the camera will select the smallest aperture possible based on the light level needed for an accurate exposure. As the light level changes, the camera will adjust the aperture accordingly (unlike in the aperture mode, where the aperture you select remains constant).

It gets more difficult to maintain sharpness with the increased magnification.

Right—An external flash on an extension cord was held above the camera and lizard so that the shadows would fall below the subject. **Below**—Parrot feathers were vividly reproduced using the close-up mode and the internal flash system.

○ USE INTERNAL FLASH

With either mode, the camera will compensate for the available light and reduce the shutter speed to a point where camera movement will blur the image. The best solution is to turn the flash from the auto position (auto and lightning bolt icon) to the always on position (lightning bolt icon). This will override the camera's decision to use sunlight only, and the flash will fire on each close-up shot you take.

When shooting close-up pictures with internal flash, you may get some overexposure. When that happens, you can usually use a flash exposure compensation menu to lower the flash level in your photo. If that doesn't

help, you may have to put some layers of tissue or other frosted material over your flash to reduce its output.

○ ADD AN AUXILIARY FLASH

On some of the more advanced cameras you will find either a hot shoe or external flash sync jack that allows you to add an external flash. You can then use both flash units to illuminate the close-up scene, or turn off the internal flash and use just the external flash. If you attach your auxiliary flash to a coiled extension cord, you can light your subject from numerous different angles and achieve a variety of lighting effects.

Above—If you use an external flash on an extension cord, you can achieve sidelighting for your close-up images of flowers. **Below**—A slave flash was used to light this large crab spider so that the shadows fell out of the field of view.

○ SLAVE FLASH

There are several new cordless slave flash units that will sync with your internal flash, fire, and then shut off with the internal flash. This can be a great way to provide some ratio lighting to your close-up images. You will find more information on using a slave flash with your digital camera in chapter 7.

○ SETTING UP YOUR CAMERA

Most zoom lenses in digital point & shoot cameras have certain restrictions on just how you use the close-up function. You can't achieve a close focus

Above—These peeling paint chips were documented with the close-up function. **Top Right**—Flowers and insects make great subjects for close-up photography. This dragonfly was photographed early in the morning as he landed on a lily pad in our garden pond. We used an external flash with a bounce card to illuminate the insect from above. **Bottom Right**—The lens was set to f/16 in the aperture mode and an external flash was used to capture the maximum depth of field in this image.

in the telephoto position. In order to get as close as possible to your subject, you should zoom the lens toward the wide-angle position. Some cameras allow you to zoom in on your recorded image on the LCD. You may use this function to zoom in to check your focus, as sometimes it is hard to judge an accurate focus using the LCD viewer.

○ CLOSE-UP TIPS

When photographing small, shy creatures with a digital camera, it is best to first get a shot from a distance so as not to spook the critter, then slowly move in or use the telephoto portion of the lens to get closer shots. Eventually, you will get to a point where you can turn on the close-up function (flower icon) and continue shooting as you move in. Even if your subject flits away, you will have at least a few shots.

Keep in mind that the resolution of most digital cameras is high enough to allow you to enlarge portions of a digital image. Using the unsharp mask in photo editing programs like Adobe Photoshop or Elements, you can even magnify your image between two to eight times and maintain quality.

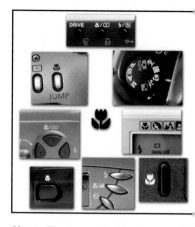

Above—The close-up function is represented by the flower icon; it can be found on the exposure mode dial or on the top or back of the camera. **Below**—This image was taken with a digital SLR camera, macro lens, and extension tubes; it provides 4x magnification.

Above—This distant photo of a skittish tree frog was taken just in case he decided to hop away before any close-up images were made. We used a single flash on an extension cable and held it off to the left side of the frog.

Right—After several establishing photos of the tree frog were made, we moved in for some extreme close-up images.

○ CLOSE-UP ADAPTERS

If your digital camera does not have a close-up function, or you want to get closer than your camera allows, there are several third-party manufacturers who make close-up adapters for digital cameras. Check with your local camera store, or do a Web search for "digital camera accessories" to find out what might be available for your particular camera model.

The sun's sidelighting highlighted the dewdrops on a leaf; we used the close-up function on a point & shoot camera to capture the moment of the morn.

12. Practical Applications

Believe it or not, there is also a practical side to the equation . . .

Up to now, we have talked about the various fun projects that you can do with your new digital camera. Believe it or not, there's also a practical side to the equation, which will help justify your camera purchase—especially to your spouse. Here are a few practical applications that take advantage of the capabilities of a digital camera.

● DOCUMENT PERSONAL BELONGINGS

Let's face it, the world is not as secure a place as it used to be. Theft and accidental breakage have become a fact of life. Many insurance companies recommend and often require that a written identification of household belongings be included with an insurance policy. This can be a very time-consuming and expensive process, so let's put the digital camera to work.

Since you don't have to consider the cost of film, you can take as many pictures as you like. When documenting the contents of your house, go room by room. Take some overall photos of each room, and then shoot close-up images of each item in the room. Open drawers and photograph

Left—When documenting items like camera equipment or stereos, first take an overall image, and then a close-up of the serial number. **Right**—Most of the serial numbers on point & shoot digital cameras are on the camera's base.

the contents. If there is a serial number involved, take an overall photo of the object, and then use the close-up function to shoot the serial number.

Check each image as you go. If you get a reflection off the metal serial number plate, shoot it slightly at an angle. Just make sure you can read the numbers. This process is especially helpful if you have camera equipment, jewelry, or collectibles and want to extend a rider on your insurance.

Make some inkjet prints of the equipment and include them with your insurance policy. When you have documented everything, you should burn the images to CD, and store them in a safe place other than your home. If you have a safety deposit box, it would be a perfect spot for one or two CDs.

○ CONSTRUCTION PROJECTS

Another fun project is to document the building of a house, garage, or other structure over the course of its construction. It's fun to view the images in sequence to see the structure emerge before your eyes. You can even create a digital slide show with one of the software programs designed to transfer all the images to CD or DVD. (See chapter 18 for more information on digital slide shows.) If you make a CD of the project, you can place it in a time capsule hidden inside a wall for someone in the future to find and enjoy.

When documenting the contents of your home, go from room to room taking images that can be used to identify your belongings in case of a disaster. Keep in mind that the only expense in taking plenty of images is the time it takes to expose them.

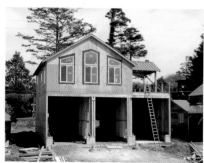

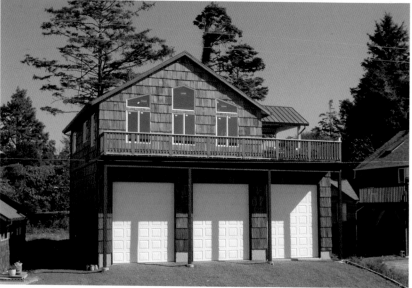

Above Left, Center, and Bottom Left—Taking digital images of a building in progress is easier since you no longer have to pay for film processing. This building took more than a year to complete, so we took more than 700 images showing the building in different stages of development. A copy of the final CD was stored as a time capsule and placed in a wall of the completed building. **Right**—This shows construction in progress for our new office and digital darkroom. We documented all the walls so that we would have visual blueprints for any future alterations.

If you are the type of person who likes to tinker with remodeling your house, you should consider using a digital camera to document modifications like new water pipes or wiring. Even if you don't do the building yourself, you should document the interior walls before they are covered with insulation and sheet rock. This will make it easier when, down the road, you decide to make another modification to your house or need to locate plumbing or wiring problems.

Whenever we rent a car, we take a series of photos before leaving the rental parking lot. Documenting any existing damage or scratches alleviates any possible controversy when returning the vehicle.

○ CAR RENTALS

When you first pick up a rental car, you must carefully go around it and make notes on each dent or scratch; otherwise the damage will be charged against you when you return the car. Even with careful inspection, you may miss something that the employees surely won't miss upon your return.

The digital camera becomes your backup insurance policy in cases like this. You can take a few shots of each side of the car, a couple close-ups of any previously damaged areas, and go on your way. The time and date on which the files were created will be recorded, so there will be no doubt that the damage was preexisting. If the rental car agency has any questions, you can always print out the files for closer inspection.

○ ARCHIVING IMAGES

It has been estimated that billions of photo prints lay discarded in shoe boxes and drawers. If any of these belong to you, then you need to consider archiving them for your grandchildren and theirs. This can be a monumental task if you scan each image one at a time on a flatbed scanner and

have hundreds to convert. Your digital camera can reduce this to a fraction of the time it takes on a scanner. Generally, all you need is a digital camera with at least a 3-mega-pixel resolution and the capability of taking close-ups.

Copy Work. Using an external flash with a digital camera is a great way to archive hundreds of photographic prints. Make sure that you turn off the internal flash using the flash control menu in the camera. Direct flash from the internal system will cause flashback and glare on your prints as you try to copy them straight-on. You can also use an external flash in conjunction with a slave flash to provide professional 45-degree lighting.

Another option is to mount your camera to a sturdy tripod and use a single tungsten light set to one side of the print. Allow the light to skim across the print with the light pointed toward the far edge. If the lighting appears uneven, you can set a white board on the opposite side to reflect back the light. Better yet, you can add a second tungsten light, positioning both lights at a 45-degree angle to the print. In a pinch, you can also use the sunlight at a 45-degree angle from the print if you have an area protected from the wind or rain in which you can do your copy work.

Removing Moiré Patterns. If you are copying any type of magazine or newspaper clippings, you will find a mottled appearance called a moiré pattern. This results because the dot screen pattern used in offset printing is not aligned with the sensor system on your camera's CCD chip. You can eliminate this problem by rotating the artwork 45 degrees when you take a photo. When you bring the image into your editing program, you will have to rotate the image back 45 degrees until it is once again straight.

If you have very dark or light prints, you may have to use the exposure compensation feature on your camera to correct for these problems. We like

Turn off the internal flash using the flash control menu in the camera . . .

Left—The efficiency and quality of the digital camera when used for copying photos make it a great alternative to scanning prints. **Right**—Mount your digital camera to a solid copy stand to avoid camera movement. Set your camera to the close-up mode and make quick work of copying your old photos.

Left—When you copy magazine and newspaper clippings, you often get moiré patterns. The upper-left image had moiré patterns so we rotated the original 45 degrees (bottom image) and eliminated the pattern. The image was then rotated in Adobe Photoshop. The clipping is of actress Zale Parry *(Sea Hunt)* talking to Tommy Smothers *(Smothers Brothers)*. **Right**—Final composite that our daughter, Kristy, used to direct fellow students to a beach campsite.

We run several tests with shutter speed and aperture variations . . .

to use manual exposure when we do a lot of copy work with our digital camera. We run several tests with shutter speed and aperture variations until we have a correct exposure. We can then do all the copy work, confident that each image will be exactly the same exposure whether the original is light or dark.

Visual Directions. Our daughter Kristy came up with an unusual application for the digital camera. She was planning a camping trip with some of her college friends and most of them had no idea how to get to the campsite. It took a lengthy trek down several roads and trails and much beach hiking to get to the remote site. She simply headed out to the campsite, taking pictures of signs, turns in the road, and any area that might cast doubt on a visiting voyager.

She then brought the pictures into Adobe Photoshop, organized the photo order, added arrows for any path intersections, added maps where needed, and made a composite of the images. She sent copies to everyone who was coming. No one got lost, and a good camping trip was had by all.

When we receive photo equipment on consignment for review, we take a visual record of how it was packed, so we know what equipment arrived and how to repackage it for the return trip. Many large companies are now using a visual record to document orders before they are shipped.

Document Your Shipments. Whenever we receive a package with equipment on consignment, we photograph the box and its contents. This helps us prove that the equipment arrived safely, documents exactly what pieces were sent, and shows us how to repackage it when it comes time to ship it back.

13. Tell a Story

In this chapter you will combine all the skills you have learned so far to use your digital camera to tell a story. It's true that some pictures can stand on their own, but often it takes more than one image to really tell the whole story. To truly convey your experiences photographically, you will need to create a variety of images to give the viewer the feeling that he or she was part of the adventure.

● TAKE PLENTY OF IMAGES

Let your photo collection reinforce all your incredible moments.

Don't be afraid to take plenty of images. Break away from the old school of thought of just taking an image or two before moving on to the next subject. This is especially hard for film camera users who are accustomed to being thrifty since each shot means additional expense for both film and prints. Images on a digital camera are simply bytes of data that cost you nothing to shoot once you are past the initial investment. So, there's no excuse for taking only one shot of a scene, other than time itself.

● BEGINNING, MIDDLE, AND ENDING

You need to start thinking like a storyteller. Most photographers tend to think of only one shot at a time. When that photo is taken, the next photo comes from a totally new thought. Instead, think of the picture story as an English composition with a beginning, middle, and end. Pictures should be a sequence of images that lead from one to the next. You don't have to make a professional production of telling a visual story, and don't worry about trying to capture everything. The idea is to have fun, and let your photo collection reinforce all your incredible moments.

Don't be afraid to take more than one photo of a situation. Remember, with digital, you can delete those images you don't like, and you only have to print those you want printed. When vacationing, take pictures of your family getting ready, in the car or at the airport, maybe one in transit, another while struggling with the luggage and, of course, one where everyone has collapsed after a hard day. You get the idea, right?

As the trip progresses, document special moments along the way. That greasy diner where you stopped for a bite to eat and the colorful flower gardens can make some interesting images. All these photos add impact to your picture diary and will later help remind you of all the fun you had. Don't forget to use the self-timer so you can be included in the photos. If you don't keep a visual record, you'll be surprised how easily the fun moments you thought you would never forget slowly fade with time. No longer will you have to say "I guess you had to be there." Now you can say, "Let me show you!"

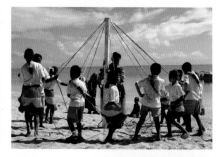
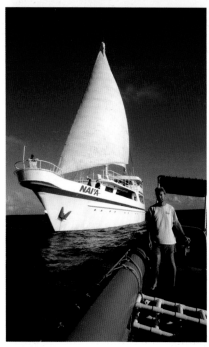
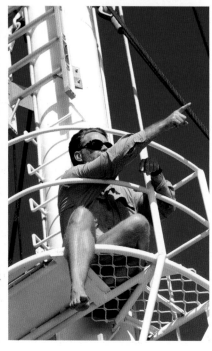

Top Left—Our story starts at the Tonga Airport. **Top Right**—We used a small point & shoot digital camera to document most of our travels. While waiting to board the boat, we made a trip through a local outdoor market. **Center Left**—One of the highlights of our trip was a local village visit. We used our digital SLR with a wide-angle lens to capture the scene. Because the lighting was low, we set the ISO to 800 so we could stop the action and obtain reasonable depth of field. **Center Right**—As the local children put on a festive display, we used a variety of focal lengths to document everything except the singing. **Bottom Left**—We used the aperture mode to ensure that the depth of field carried from the owner of the boat to his lady sailing behind him. **Bottom Right**—We used a telephoto lens from a low angle to document the first whale sighting from the crow's nest.

Top Left—Once the whales had been spotted, we switched to a digital SLR camera with a long focal length lens and set the ISO to 800. We selected the sports mode so that the camera would select the highest shutter speed possible, while maintaining an accurate exposure. **Top Right**—We tried to capture the excitement of the snorkelers heading out to visit the whales and the elated but weary group upon their return. **Left and Right Center**—The sports mode was used to document the forty-ton whales as they breached off the bow. With an index finger pressing halfway down on the shutter, we were prefocused and poised to capture the action. **Bottom**—As cliché as it may be, we photographed a sunset to provide a happy ending for our story.

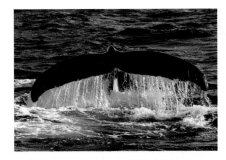

○ VARY YOUR PERSPECTIVE

Use your new photo skills to illustrate your story. Changing your point of view to a different angle can add impact and variety. After you have taken an eye-level photo, point the camera down on the subject. Then hold it low to the ground and shoot up at the subject. You will be surprised what a difference it makes when you capture your subject from different vantage points.

Change your lens focal length to add variety to your photos. Use the zoom to isolate your subject from the background. Provide perspective by using wide-angle lenses to add depth to an otherwise normal image.

○ LIGHTING

Another perspective variation is the lighting. Move around your subject and try taking a picture with the sun over your shoulder. Then try it with

Top Left—This branch found in a nearby lake seems to have withstood the elements of time. It is quite unique, so we photograph it on a regular basis just to see it change moods with the shifting impact of Mother Nature. **Top Right**—Another day and a different camera gave us a new perspective. For this foggy morning photo we switched from a vertical to a horizontal format. **Bottom**—A lower camera angle gave us yet another view.

the sun to the side, and finally with the sun behind your subject. When you shoot with the sun behind the subject, try letting the camera calculate the exposure first, and then use the exposure lock or backlight feature to vary the exposure. Try taking photos with and without flash to achieve different lighting effects.

Preview the images as you go. If you have trouble seeing the LCD viewer, move to a shady spot, or turn your back to the sun. Cameras with an LCD viewer inside the eyepiece provide easy viewing in any type of lighting situation.

○ SAME SUBJECT, DIFFERENT TIMES OF DAY

We like to repeatedly photograph a subject over an extended period of time. Taking digital pictures of a scene in the early morning, midday, afternoon, and around sunset can make for some spectacular photos. Make sure that you vary the shots with different angles, perspective, and a variety of lens focal lengths. Repeat the process when the weather changes, and you are presented with a whole new set of lighting conditions.

Create a special directory on your computer to store your images. Once you feel you have enough shots, you can work on creating a collage of images. Select a neutral background in your favorite editing program and add each of your images. You can spice it up by using edge filters, adding a title, drop shadows, and other creative tools to make your collage interesting. When you are satisfied with your efforts, you can print it out on your inkjet printer.

Create a special directory on your computer to store your images.

○ SAME SUBJECT, DIFFERENT SEASONS

Another interesting project is to shoot the same exact scene from the same position as it changes over the four seasons. The subject matter can be a wide-angle landscape or a small nature subject. Since Mother Nature's artistry is ever-changing, we recommend that you shoot at least one picture a month and then select those that best depict the changing seasons.

You don't even have to photograph spectacular subjects, as they take on a new meaning when grouped together. For example, we live near the beach, and we take a digital camera with us on our daily walks. Along the way there is lake with an old tree branch that rises from the depths and resembles a sea monster. We continually photograph the same branch year-round in the early morning, late afternoon, when the weather is dead calm, windy, hot, cold, and icy. All these moods add to the flavor of capturing one object through the passing of time.

○ IMAGE STORAGE

If you are going on a long trip and plan to document it using your digital camera, you should consider some image storage options for your trip. There are three varieties from which you can choose.

Add Memory Cards. First, you can buy additional memory cards to ensure that you have more than enough storage space for the trip. The price of these memory cards has dropped considerably, so now you can afford several.

Include Your Laptop. If you plan on taking your laptop, you could download the images onto your laptop as your trip progresses. If you have a CD or DVD burner in the laptop, bring some blanks and burn backup copies of your files. If anything happens to the laptop, you still have archived images. Laptops can be replaced, but photo memories cannot.

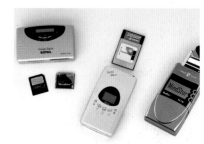

Portable Hard Disks. The third option is a portable hard disk, which will allow you to download your images directly from your memory card. At first glance, these devices look like an old GameBoy. Generally they will accept CompactFlash and Smart Media cards, with adapters for the other types of memory cards. Most units cost between $250–500 and range from 5 to 40 gigabytes (G) of storage, which means they can hold thousands of digital image files.

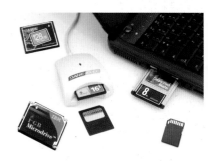

Top—Portable hard disks are becoming popular since they can hold from 5 to 40G of data. They can provide temporary storage for thousands of images. **Bottom**—If you have space for a laptop on your trip, you can transfer your images onto the hard disk, preview them, and even archive them to CD or DVD.

14. Creating Panoramas

There are some scenes that just demand a full 360-degree circular panorama.

Photographers have always had a fascination with panoramic pictures, but the task of shooting and assembling them was time consuming and labor intensive. The process was also very expensive because of the number of film frames needed for each shot. Printing and assembling multiple prints into one final image was a complex and challenging process.

The digital camera makes creating panoramics easy and inexpensive. Best of all, anyone with a digital camera can do it. With software, the digital process of creating a panorama is divided into two tasks—the creation of the panoramic parts and the assembly of the pieces into one combined file.

● SETTING UP YOUR CAMERA

You first need to prepare your camera for imaging the panorama parts that will be used to assemble the final image. As you create the different pieces, you will rotate the camera, thus encountering different lighting conditions along the way. You must keep the exposure constant in order for all the pieces to blend together. Set your camera to the manual mode, and point the camera at the area with the brightest light level. Most cameras have an exposure bar so that you can adjust your shutter speed and f/stop for a correct manual exposure. Take a test shot to confirm that you have a good exposure. If not, adjust as necessary and test until you are satisfied with the exposure. Be sure to delete these test shots so they are not confused with the final series.

● CREATING THE PIECES

There is no rule on how wide to make your panorama. Some will need to be wide, just because there is a lot in the scene. Others may just take just three or four parts to create the right effect. There are some scenes that just demand a full 360-degree circular panorama.

You can try handholding your exposures, but we find that a monopod works even better. There are plenty of books that recommend using a tri-

pod, but we find that they are time consuming. Unless your tripod has an extremely accurate bubble level and your camera is perfectly level, you will spend more time attempting to get it level than actually shooting the panorama.

Are you ready? Let's give it a try. Align the horizon so it is in the middle of the LCD viewer and as level as possible. Take your first picture, and then carefully rotate the camera so that you have at least 25 percent of the previous scene still in the frame. Take a second image and continue using this same overlapping method until all the panorama parts are exposed. For insurance, we recommend that you shoot a second set of images.

Some of the more recent digital cameras actually have a menu mode for panoramas that places an overlapping line in the viewer to help you accurately shoot each piece.

If your camera has a multi-sequence function (under the shutter control menu), you can press the shutter button and pan in a circle while the camera shoots dozens of overlapping images and saves each as a separate file. More on this feature in chapter 15.

You don't have to restrict your panoramas to landscape photography. Yes, they make great panoramas, but use your imagination; you will be surprised to see that often scenes with close objects also make some very interesting panoramas.

Below—This image was created using four digital images stitched back together using a panorama program. **Right**—Each panorama part should overlap the previous by at least 25 percent.

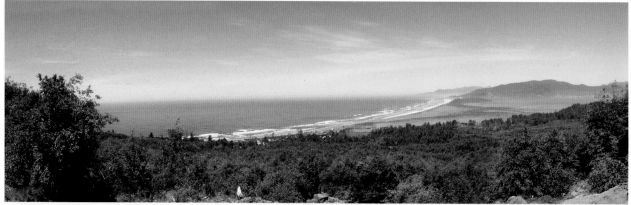

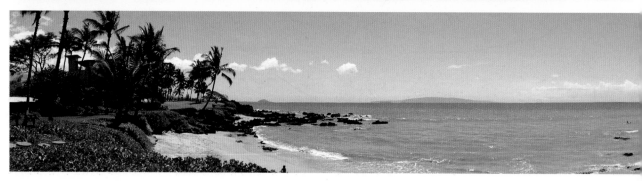

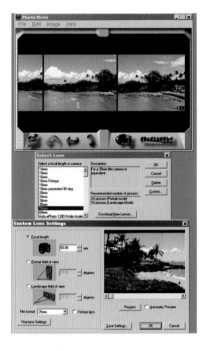

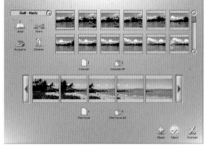

Left—Panorama stitching programs have a variety of menus that allow you to set the order of the parts and provide information about the focal length and camera brand used. You can then have the program automatically assemble the panorama, or you can adjust each piece manually. **Center**—Some digital cameras actually have a panorama grid that helps you align the pieces as you take them. **Right**—Most software programs provide flexibility in panorama assembly.

Once you get the knack of shooting the pieces, you can even try your hand at a vertical panorama in three to five pieces. Use the same process of overlapping images, but change your direction to up and down instead of left and right. You can make some very interesting images of tall trees and buildings.

○ ASSEMBLING THE PARTS

This part of the process is easy. There are more than a half dozen panoramic stitching software programs on the market, and they all seem to work well. Once you tell the program where your files are located, it will proceed to load them one at a time. You will need to supply information about the camera and lens you used to take the photos. Once that is completed, you can manually align the pieces or let the computer automate the process. Some programs will even let you fine-tune the adjustments once the initial alignment is made. The program will crop the final image to eliminate any uneven edges caused by the stitching process.

Make sure that you don't edit any of the panorama parts by cropping or color balancing the pieces until the final panorama is completed. If you do, there is a chance that the panorama will have unevenness as the images merge. You can do any final editing once the image has been fully assembled.

Below—A very wide panorama created in Hawaii from seventeen digital point & shoot camera pieces.

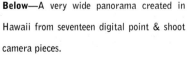

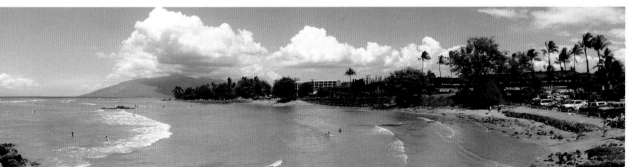

15. Animate Your Images

Digital cameras offer many features not found on film cameras. One of the most unusual features is the multi-image function, which can be found under the shutter control menu. Once you reach this menu, you have several choices from which to select. *Single shot* means that each time you press the shutter one image is exposed. In the continuous mode, the camera will shoot consecutive images until the memory buffer is full. Then the camera will stop and transfer all images from its internal memory to your removable memory card. The movie mode shoots either low or high-resolution movies, depending on the type of digital camera you own.

...the camera will shoot consecutive images until the memory buffer is full.

◉ MULTI-IMAGE SEQUENCE

This control setting is rarely used and its name varies from one camera manufacturer to the next. You might see it called the HS sequence, ultra-high-speed, or multi-image sequence function, but they all work about the same. In this setting, the camera records a movie, except that it creates separate files for each frame in your animation sequence. Each camera will have a different frame-per-second rate (three to thirty), image resolution (320x240 up to 1280x960), and maximum number of images it can shoot

The high-speed sequence control is usually part of the continuous menu on cameras that support this function. Its resolution can range from full resolution down to computer-screen resolution.

This is a composite that includes four images from of a series of fifteen high-speed sequence images.

in a sequence (thirty up until when the memory card is full). While this possibility is pretty exciting, you are probably scratching your head wondering just what you would do with such a feature.

360-Degree Panoramas. Set your shutter speed fairly high, press the shutter, and slowly pan in a 360-degree circle, taking a couple dozen images as you go. The exposure setting is frozen during the entire sequence to assure there is no exposure variation from image to image. Since the camera takes multiple images as you slowly pan, this provides more than enough images to overlay and create some great panoramas.

Set your shutter speed fairly high, press the shutter and slowly pan in a circle . . .

To animate your pan, import the parts into one of the many 360-degree panorama software programs and allow it to assemble your image. Once completed, you can then use a 360-degree pan viewer to move left or right in a circle as you move around in the scene. If you used a wide-angle lens for the panorama, you will even be able to move up and down in the scene. These 360-degree panorama files can then be packaged with a special viewer and sent via e-mail to friends and family.

Stop Action. Most professional motion picture cameras have a function where you can shoot just a few frames a second instead of the standard rate of around thirty per second. If you have someone slowly move through a scene taking tiny steps and then play it back at normal speed, they zoom across the screen. The most famous use of this technique was during the chase scenes in the British television series, *The Benny Hill Show.*

You might be asking yourself what this has to do with your digital still camera. Well, if you attach your camera to a tripod, and set it to the high-speed sequence series, you too can create your own funny stop-action movies. The key is to have each person shuffle, taking short steps as they move through the scene.

Final Presentation. So now that you've got it, what do you do with it? There are several inexpensive digital video editing programs that allow you

Dscn7399.jpg Dscn7401.jpg Dscn7403.jpg Dscn7405.jpg Dscn7407.jpg

Dscn7409.jpg Dscn7411.jpg Dscn7413.jpg Dscn7415.jpg Dscn7417.jpg

Left—Animated panoramas are created like a standard panorama except that it takes more pieces to complete the entire 360-degree circle. Here we show fifteen high-speed sequence images that were taken as the photographer moved in a circle. **Below**—The 360-degree panorama before it was converted to an animated panorama. **Bottom**—Several companies make viewing programs that allow you to move around in a circle with your mouse.

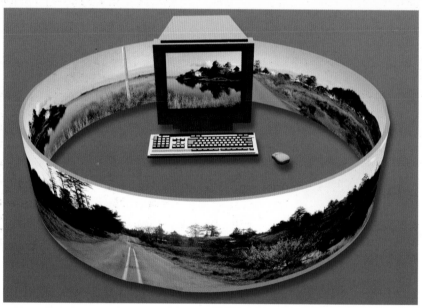

to mix video, stills, and sound on your home computer. Simply import the series of still images into one these programs and the final output file will be in AVI or MOV file format. This can then be transferred to VHS, VCD, or DVD and viewed on your television or computer. For more on how this is done, refer to chapter 18.

16. Digital Camera Accessories

The good news is that most of the accessories you bought for your film camera will work just as well with your digital camera.

● FILTERS

Take filters, for example. Filters come in hundreds of sizes and colors and are made for almost every photo application. Most screw on to the front of your camera via a set of fine threads. Since many of the new digital cameras have thread sizes different from film cameras (usually smaller), you will need a couple of step down or step up (adapter) rings to attach them. Since many of the digital cameras have lenses that retract into the camera body, be sure your filters fit properly so they don't jam in the camera.

There are filters manufactured especially for digital cameras too. They usually are created for a specific brand camera, and will attach directly to the lens without the use of any adapters.

Polarizers. Your first choice of filters for your camera should be a polarizer. This filter is made up of hundreds of very fine lines that block various portions of reflecting light. As you rotate the front ring, blue skies will become darker and reflections will disappear.

There are filters manufactured especially for digital cameras too.

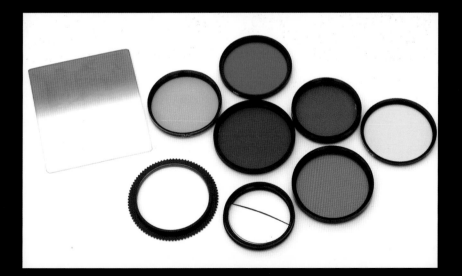

Filters used with film cameras can also be used on digital cameras.

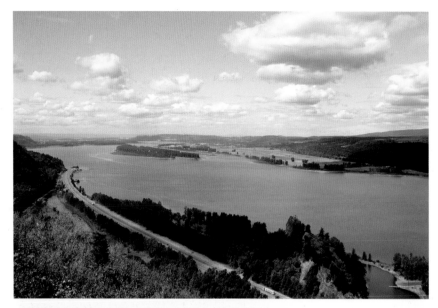

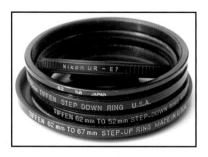

Some digital cameras have a smaller filter thread size and may require adapter rings to accept the larger filters.

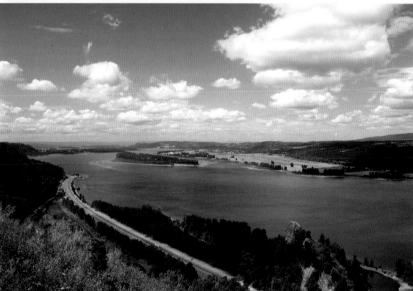

Top—With its breathtaking views and superb visibility, the Columbia Gorge is a great place to take wide-angle landscapes. This image was taken with a 20mm lens on a digital SLR camera without any filters. **Above**—We attached a polarizing filter and rotated it until we achieved maximum contrast between the clouds and the sky.

Creative Filters. Creative filters include starburst, color diffraction, rainbow, multi-image, repeaters, split focus, and color gradation filters. Because some of these filters rely on certain size apertures to achieve different effects, the playback image might be different from the LCD preview image. Experiment with different apertures and shutter speeds until you have a preview image you like.

Close-up Filters. For those cameras that don't focus close enough to capture some of Mother Nature's delights, you can add a special close-up diopter filter. Added to your normal lens, these auxiliary filters will force

your lens to focus closer. These filters range from +1 diopter to +4 diopter, and a special life-size diopter is even stronger. You will be able to see your approximate results in the viewer, but you should play back the recorded image to be sure you achieved the proximity you were after, as small apertures often provide different results than the preview.

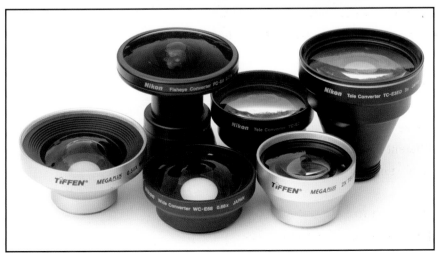

Above—The close-up diopters attach directly to the front of any point & shoot camera lens, allowing closer focus than is possible with the normal lens. **Left**—The most common accessory lenses made for digital cameras are wide-angle, telephoto, and close-up converters. Most brand-name and third-party adapters attach directly to the camera lens or via an adapter.

⦿ LENS CONVERTERS

The capabilities of the digital camera can be greatly expanded with the addition of lens converters. These screw-on lenses generally come in four types—telephoto, wide-angle, close-up, and fisheye.

Lens converters are made by both brand-name manufacturers and third-party vendors. To find them for your camera, log on to the Web and do a search for "digital camera lens converters," or "digital camera accessories."

Telephoto. The telephoto converter allows you to magnify distant objects more than is possible with your digital camera's maximum zoom setting. The result is that distant objects will better fill the frame, providing a closer view of subject detail.

Wide-Angle. The wide-angle converter extends the view of a scene beyond that achieved when your camera is set to its most wide angle. This is a great tool for those situations where you have your back against the wall and you still can't get all of the scene in the frame.

Close-Up. The close-up converter is a high quality optical lens that attaches to your standard lens and allows you to photograph smaller creatures than you can with your camera's close-up setting. These lenses have the added feature of keeping your camera further away from the subject than when using a close-up diopter or just the camera's close-up position. This is especially useful when you have creatures that move if you get too close.

Fisheye. The fisheye lens provides a whole different view of the world. In truth, it gives you an extremely distorted but unique view. These lenses have an almost limitless depth of field and allow you to shoot extremely close to subjects and still maintain focus on objects in the background.

> The telephoto converter allows you to magnify distant objects . . .

Left—This giant aquarium was photographed with a wide-angle converter attached to a point & shoot camera. **Below**—The fisheye converter is the widest angle lens you can use with your point & shoot camera. This lens attaches to the front of the camera with a special lens adapter.

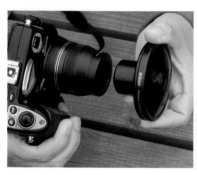

We laid the camera with a fisheye lens on a wooden deck and positioned the swivel LCD so it pointed the same direction as the lens. Once the self-timer was activated, the photographer had about eight seconds to line up the shot.

If you want to minimize the distortion, hold the camera perfectly level and have the horizon run straight through the middle of the picture. The greatest distortion occurs when you point the lens up or down from a level horizon. You can get some really interesting shots if you place the camera at a very low angle close to an object and point it straight up into the air. Some cameras have LCD viewers that rotate backward and allow you to preview from various positions; these are a plus when using the fisheye conversion lens. Be aware, though, that the front element on this lens is usually very large and unprotected. Take extra care when shooting close to objects so they don't touch the lens.

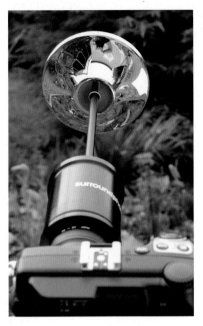

Opposite—The moveable LCD viewer makes it easy to take a picture from a low vantage point with a fisheye lens. **Above**—This one-of-a-kind device for digital cameras attaches to the front filter threads and projects a full 360-degree image onto your camera CCD. Special software is then used to decode the image into a 360-degree panoramic image.

○ 360-DEGREE PANORAMA

One of the strangest digital camera accessories works on both film and digital cameras. The 360-degree panoramic capture device is a mirror system that attaches to the front of your camera lens and reflects a circular image through the lens into your camera's recording device. The digital file is then converted through special software into a 360-degree panorama that can be animated or printed on long inkjet paper. Film camera users must have the film image scanned and converted to a digital file before it can be converted into a 360-degree panorama. See chapter 18 for points on printing long prints.

17. Cataloging Images

Once you get the hang of using a digital camera, you will quickly collect a lot of images. You will also find that it can be frustrating to find just the one image you want when you need it. This is why you need a reliable photo database program to help you find your images—by either a visual exploration or a search engine. There are dozens of database programs available today, and there is also a good chance that one was included with the purchase of your camera.

● WHAT SHALL WE NAME IT?

Before we start the image cataloging process, we need to talk about naming images. Most digital cameras have two methods for naming files that can be set up in the file naming section. The first method resets the numbering system each time you download images to your computer. This is not very practical because there is always the possibility that you will overwrite images with the same file name.

Consecutive Numbering. The best solution is a consecutive numbering system that keeps track of how many images you have taken on your camera. When you put a new memory card in the camera, it starts to number from where you left off. Most of these numbers make little sense, and may be in a sequence like dcf00001.jpg and dcf00002.jpg.

EXIF Files. So, how can you make better sense of these files? The solution lies in the new EXIF format, which most digital cameras support. Although versions vary, they usually allow you to rename the files with a short name in front of the date as you download them to your computer. The resulting file name might be MyHouse_2003_07_07_02. Since these files will be sorted in chronological order, they will be presented in the sequence in which they were created. Because you rely on the date in the camera to name the file, it is very important to keep the date accurate to ensure chronological order.

> Although versions vary, they usually allow you to rename the files . . .

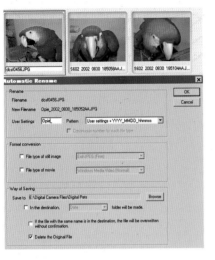

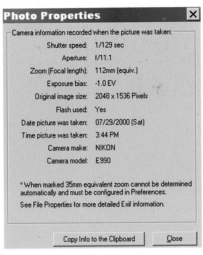

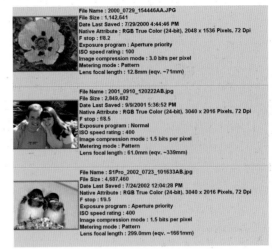

Left—Many of the EXIF file importers for digital cameras allow you to rename the file before transferring it to your computer's hard disk. Center—You can also directly access digital camera files and look at the EXIF camera information. Right—The camera data is stored in a digital camera EXIF file and will import directly into most photo database programs. You can select the data fields you want displayed and they will appear under your thumbnail image.

VISUAL PHOTO DATABASE

Next we'll cover database software programs. Some of these are included with your digital camera, and other reasonably priced versions are readily available for cataloging your digital files, as well.

Here's how they work: Simply tell the program where the images are located and it will immediately go to work cataloging the images, creating thumbnails. If your camera supports the EXIF digital file format, the program will add any digital camera information that may have been saved with the file.

Once the cataloging is complete, you will have a picture database that you can visually scan to look for specific images. You can also use the search engine to look for a specific file name, image type, file size, or date. Most programs will also have an information section where you can add the location or other pertinent data about the image.

NOW YOU'VE FOUND IT, WHAT TO DO?

Once you have found a specific image in your new photo database, you can zoom in to a full-screen magnification for better viewing, or send it out for printing. If you want to edit a picture in a database, you can drag the file to a photo editor icon on your work screen and the program will open and load that specific image. Once the file has been edited and saved, you can update your photo database thumbnail to reflect the changes.

One word of warning! If you don't want to lose the digital camera information stored with the EXIF format, you should save your edited file under a new file name. This allows you to go back to the original file for the EXIF information or to reedit the original image.

Slide Viewer. One of the nicest features included with database programs is the slide viewer. When you view your thumbnail database, it is much like reviewing images on a light box. The problem is that a thumbnail image is

Ulead Photo Explorer will even allow you to gather files from the photo database and preview them as a slide show.

Top Left—A good database program, like Ulead PhotoImpact, will allow you to select thumbnails and convert, copy, or drag them into other editing programs like Adobe Photoshop, Corel Painter, or Deneba Canvas.

Top Right—Several new photo database programs (like ACDSee) are available. These provide a large thumbnail of the selected image, smaller thumbnails of your directory, and EXIF camera information about the selected file.

small and it can be hard to discern intricate detail. With the database slide viewer, you can move images around, select an order for viewing, and then save the sequence. When you press the start button, your selected slide show can be viewed full screen. For more on the use of slide show formats, check out chapter 18, "Sharing Your Photos."

18. Sharing Your Photos

Okay, the picture was taken, saved to a memory card, and transferred to your computer system. Now what do you do? Actually, you have many directions to go from here.

◉ USING YOUR EDITING PROGRAM

The main point of taking digital images is so that you can share them with your friends and relatives. As good as digital cameras are today, they are not perfect. You may want to consider a small amount of editing to perfect your digital moment in time. Many of the photo editing programs today have an auto correction feature that allows the computer to fix the photo. Try it first, but if that doesn't work, you should use the undo function, and use the brightness, contrast, and color controls to manually make any final adjustments to your photo.

Many of the photo editing programs today have an auto correction feature . . .

Most digital camera files can use some cropping to improve their composition and quality. Adobe Photoshop and Elements darken the area to simulate the appearance of the cropped image.

Give It a Crop. Don't stop there! Many times the biggest difference between a so-so photo and a great one is the way it is cropped. Every photo editing program we have seen to date has had a control to crop out unwanted space or objects in the picture.

Just because the camera shot your image in a specific format and size, doesn't mean you're stuck with it. A standard sunset picture can be turned into a dynamic panorama merely by cropping off the top and bottom of the picture. You can remove the unwanted hand sticking in from outside the picture with the press of a button.

With digital cameras that are more than 3 megapixels, you can even zoom in on certain portions of an image, crop, and create a close-up version. Make sure that you save any changes as a new file so you can go back and modify the original at another time.

The archival quality of inkjet paper has evolved beyond photographic prints . . .

○ OUTPUT YOUR FILE

Once you have your final edited digital image, you are ready for the last step in the digital process—output. If you don't have the capabilities of printing your own digital pictures, you can take your memory card, or images saved to CD, down to your local photo lab. Most larger photo stores now feature printing services for digital camera files. You can even save money by previewing your images ahead of time and selecting only the ones you want printed. No more double prints of blank, out-of-focus images. Yeah!

Inkjet Printers. Inkjet printers have decreased in price and increased in quality. Today, images printed at home on your inkjet printer are as good as or better than traditional photographic prints. They are still pricier than photographic prints, but you have full control over size, color, and every aspect of the final print. The archival quality of inkjet paper has also evolved beyond photographic prints, with many lasting in excess of thirty years without fading. There are even some that are plastic coated, scratch resistant, and waterproof—and they're available for different paper surfaces and thicknesses.

Multiple Prints. There are several software programs that have been developed to accommodate the needs of the budding digital photographer. With these programs, you have the option of printing single images, multiple copies, different sizes, wallet photos, or a mixture of all of these—all on one sheet of inkjet paper. You can even add borders, text, or just about anything else you can imagine.

Greeting Cards, Calendars, and More. You will find that there are printing software programs to do just about everything. You can take your digital camera files and create business cards, calendars, greeting cards, T-shirt iron-ons, party banners, and more.

Several printing programs allow you to combine multiple images and then print them at various sizes on one piece of paper.

Left—There are a wide variety of project programs available so the digital photographer can create calendars, greeting cards, business cards, and more.
Below—Numerous Adobe Photoshop–compatible plug-in programs offer a wide variety of masks and edges to enhance the printed image.

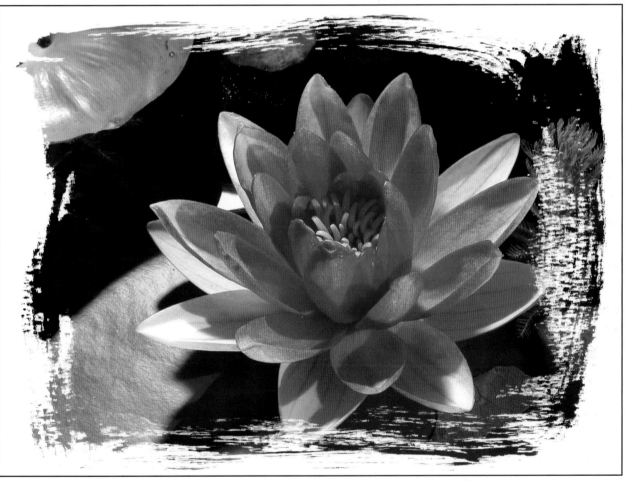

Some of the more advanced inkjet printers accept long rolls of paper, which makes them ideal for dabbling in the art of panoramic photography. To make sure your panorama will fit on your inkjet paper, you will have to resize the height of your panorama to match the paper width. You then need to look at the length of the proposed print size to make sure your paper is long enough for the print. If all things check out, then you are ready to roll.

Archive to CD and DVD. The CD and DVD burners have become very popular in the computer world. The CD is the most popular way to archive digital images you have taken. For just pennies, you can store up to 700MB and guarantee that your images are safe.

The DVD units continue to improve in quality and the prices have dropped from thousands to just a few hundred dollars. You can store up to 4.7G worth of images from your digital camera on DVD—that's seven times more than with CD. Once the files have been burned onto one of these media, you can replay your images on your computer screen or television via a DVD player.

Top—There are even CD and DVD presentation programs, like Flipbook, that will collect your digital files, create an electronic photo scrapbook, and allow you to present it on TV, CD, or DVD. **Bottom**—As you touch each page of a Flipbook, it will actually turn and present you with the next photo page in the book.

Above Left—DVD is now a popular format for storing image files, and presenting slide shows or videos. They are created on a device much like a CD burner. The DVD blanks have dropped down below $1.00 apiece. **Above Center**—Ulead DVD PictureShow is just one of the software programs that allow you to collect your digital files and make a slide show on CD or DVD. **Above Right**—Ulead DVD Workshop allows you to combine still and video images created on your digital camera with video clips from your video camera. All these sources can be mixed with music and output to TV, CD, or DVD for viewing.

Most of the new photo editing programs today have the ability to create Web pages so that you can easily share your digital images over the Web.

Audio and Movies. Some cameras have a note-taking function that will allow you to add an audio file to the images as you shoot. This is handy if you need to record pertinent information about the location or camera data beyond what the EXIF file captures.

Some subjects are hard to capture on a single frame, like children on a swing, or dogs running on the beach. In order to capture this action, most digital cameras include a function that allows you to shoot movies in addition to stills.

Digital Slide Shows. You now have the option of mixing your still and movie images in a digital slide show format. The easiest way is with a CD/DVD slide show creator program like EZ CD Creator or Toast from Roxio. Basically these programs collect your images and burn them to CD or DVD and add a special viewing program that starts when the disk is inserted into your DVD player. These shows can be transferred to VHS, DVD, or Internet shows that you can send to your family and friends.

If you want more control over your digital slide show, you can use more sophisticated software programs like Ulead PictureShow or MediaStudio Pro and Adobe Premiere. They allow you to add sound and transitional effects that rival Hollywood effects. You no longer have to worry about slide trays, slide mounts, slide jams, dust, and the many other problems attributed to previous slide shows.

Internet Connection. The popularity of the Internet has created a very fast and convenient way of sharing your images. At first, the system was slow and allowed transfer of only small, low-resolution files, but the higher speed systems now allow you to send megabytes of picture data in minutes. New Internet compression techniques, like those in Adobe Photoshop and Elements, have been developed to optimize both speed and quality. That way, viewers on either end get the best of both worlds.

Final Thoughts

It's true—digital cameras are changing the way we take photographs.

1. We take more images because of the reduced cost.

2. We take better pictures because we can immediately see our recorded image.

3. We learn from our mistakes because we can modify our efforts and try it again.

4. We can share our images more easily with friends and family.

5. We become more enthusiastic about photography, so we take more pictures. . . .

It's true—digital cameras are changing the way we take photographs.

Index

Other Books from
Amherst Media

Digital Imaging for the Underwater Photographer

Jack and Sue Drafahl

This book will teach readers how to improve their underwater images with digital imaging techniques. This book covers all the bases—from color balancing your monitor, to scanning, to output and storage. $39.95 list, 6x9, 224p, 100 color photos, order no. 1727.

Photo Salvage with Adobe® Photoshop®

Jack and Sue Drafahl

This indispensible book will teach you how to digitally restore faded images, correct exposure and color balance problems and processing errors, eliminate scratches and much, much more. $29.95 list, 8½x11, 128p, 200 full-color photos, order no. 1751.

Basic 35mm Photo Guide,
5th Edition

Craig Alesse

Great for beginning photographers! Designed to teach 35mm basics step-by-step—completely illustrated. Features the latest cameras. Includes: 35mm automatic, semi-automatic cameras, camera handling, f-stops, shutter speeds, and more! $12.95 list, 9x8, 112p, 178 photos, order no. 1051.

Freelance Photographer's Handbook

Cliff & Nancy Hollenbeck

Whether you want to be a freelance photographer or are looking for tips to improve your current freelance business, this volume is packed with ideas for creating and maintaining a successful freelance business. $29.95 list, 8½x11, 107p, 100 b&w and color photos, index, glossary, order no. 1633.

Infrared Landscape Photography

Todd Damiano

Landscapes shot with infrared can become breathtaking and ghostly images. The author analyzes over fifty of his compelling photographs to teach you the techniques you need to capture landscapes with infrared. $29.95 list, 8½x11, 120p, 60 b&w photos, index, order no. 1636.

Wedding Photography

CREATIVE TECHNIQUES FOR LIGHTING AND POSING, *2nd Edition*

Rick Ferro

Creative techniques for lighting and posing wedd portraits that will set your work apart from competition. Covers every phase of wedding phot raphy. $29.95 list, 8½x11, 128p, full-color pho index, order no. 1649.

Professional Secrets of Advertising Photography

Paul Markow

No-nonsense information for those interested in business of advertising photography. Includes: ho catch the attention of art directors, make the best and produce the high-quality images your cli demand. $29.95 list, 8½x11, 128p, 80 photos, in order no. 1638.

Infrared Photography Handbook

Laurie White

Covers black and white infrared photography: fo lenses, film loading, film speed rating, batch test paper stocks, and filters. Black & white photos illus how IR film reacts. $29.95 list, 8½x11, 104p, 50 b photos, charts & diagrams, order no. 1419.

How to Operate a Successful Photo Portrait Studio

John Giolas

Combines photographic techniques with prac business information to create a complete guide b for anyone interested in developing a por photography business (or improving an exist business). $29.95 list, 8½x11, 120p, 120 pho index, order no. 1579.

Fashion Model Photography

Billy Pegram

For the photographer interested in shooting c mercial model assignments, or working with mode create portfolios. Includes techniques for dram composition, posing, selection of clothing, and m $29.95 list, 8½x11, 120p, 58 photos, index, order 1640.

Creating World-Class Photography

Ernst Wildi

Learn how any photographer can create technically flawless photos. Features techniques for eliminating technical flaws in all types of photos—from portraits to landscapes. Includes the Zone System, digital imaging, and much more. $29.95 list, 8½x11, 128p, 120 color photos, index, order no. 1718.

Black & White Portrait Photography

Helen T. Boursier

Make money with b&w portrait photography. Learn from top b&w shooters! Studio and location techniques, with tips on preparing your subjects, selecting settings and wardrobe, lab techniques, and more! $29.95 list, 8½x11, 128p, 130+ photos, index, order no. 1626.

The Beginner's Guide to Pinhole Photography

Jim Shull

Take pictures with a camera you make from stuff you have around the house. Develop and print the results at home! Pinhole photography is fun, inexpensive, educational and challenging. $17.95 list, 8½x11, 80p, 55 photos, charts & diagrams, order no. 1578.

Stock Photography

Ulrike Welsh

This book provides an inside look at the business of stock photography. Explore photographic techniques and business methods that will lead to success shooting stock photos—creating both excellent images and business opportunities. $29.95 list, 8½x11, 120p, 58 photos, index, order no. 1634.

Profitable Portrait Photography

Roger Berg

A step-by-step guide to making money in portrait photography. Combines information on portrait photography with detailed business plans to form a comprehensive manual for starting or improving your business. $29.95 list, 8½x11, 104p, 100 photos, index, order no. 1570.

Professional Secrets for Photographing Children
2nd Edition

Douglas Allen Box

Covers every aspect of photographing children on location and in the studio. Prepare children and parents for the shoot, select the right clothes capture a child's personality, and shoot storybook themes. $29.95 list, 8½x11, 128p, 80 full-color photos, index, order no. 1635.

Special Effects Photography Handbook

Elinor Stecker-Orel

Create magic on film with special effects! Little or no additional equipment required, use things you probably have around the house. Step-by-step instructions guide you through each effect. $29.95 list, 8½x11, 112p, 80+ color and b&w photos, index, glossary, order no. 1614.

McBroom's Camera Bluebook, *6th Edition*

Mike McBroom

Comprehensive and fully illustrated, with price information on: 35mm, digital, APS, underwater, medium & large format cameras, exposure meters, strobes and accessories. Pricing information based on equipment condition. A must for any camera buyer, dealer, or collector! $29.95 list, 8½x11, 336p, 275+ photos, order no. 1553.

Family Portrait Photography

Helen Boursier

Learn from professionals how to operate a successful portrait studio. Includes: marketing family portraits, advertising, working with clients, posing, lighting, and selection of equipment. Includes images from a variety of top portrait shooters. $29.95 list, 8½x11, 120p, 123 photos, index, order no. 1629.

The Art of Infrared Photography, *4th Edition*

Joe Paduano

A practical guide to the art of infrared photography. Tells what to expect and how to control results. Includes: anticipating effects, color infrared, digital infrared, using filters, focusing, developing, printing, handcoloring, toning, and more! $29.95 list, 8½x11, 112p, 70 photos, order no. 1052.

Photographer's Guide to Polaroid Transfer, *2nd Edition*

Christopher Grey

Step-by-step instructions make it easy to master Polaroid transfer and emulsion lift-off techniques and add new dimensions to your photographic imaging. Fully illustrated to ensure great results the first time! $29.95 list, 8½x11, 128p, 50 full-color photos, order no. 1653.

Black & White Landscape Photography

John Collett and David Collett

Master the art of b&w landscape photography. Includes: selecting equipment (cameras, lenses, filters, etc.) for landscape photography, shooting in the field, using the Zone System, and printing your images for professional results. $29.95 list, 8½x11, 128p, 80 b&w photos, order no. 1654.

Wedding Photojournalism

Andy Marcus

Learn the art of creating dramatic unposed wedding portraits. Working through the wedding from start to finish you'll learn where to be, what to look for and how to capture it on film. A hot technique for contemporary wedding albums! $29.95 list, 8½x11, 128p, b&w, over 50 photos, order no. 1656.

Marketing and Selling Black & White Portrait Photography

Helen T. Boursier

A complete manual for adding b&w portraits to the products you offer clients (or offering exclusively b&w photography). Learn how to attract clients and deliver the portraits that will keep them coming back. $29.95 list, 8½x11, 128p, 50+ photos, order no. 1677.

Composition Techniques from a Master Photographer

Ernst Wildi

In photography, composition can make the difference between dull and dazzling. Master photographer Ernst Wildi teaches you his techniques for evaluating subjects and composing powerful images in this beautiful full-color book. $29.95 list, 8½x11, 128p, 100+ full-color photos, order no. 1685.

Macro and Close-up Photography Handbook

Stan Sholik & Ron Eggers

Learn to get close and capture breathtaking images of small subjects—flowers, stamps, jewelry, insects, etc. Designed with the 35mm shooter in mind, this is a comprehensive manual full of step-by-step techniques. $29.95 list, 8½x11, 120p, 80 photos, order no. 1686.

Innovative Techniques for Wedding Photography

David Neil Arndt

Spice up your wedding photography (and attract new clients) with dozens of creative techniques from top-notch professional wedding photographers! $29.95 list, 8½x11, 120p, 60 photos, order no. 1684.

Infrared Wedding Photography

Patrick Rice, Barbara Rice & Travis Hill

Step-by-step techniques for adding the dreamy look of black & white infrared to your wedding portraiture. Capture the fantasy of the wedding with unique ethereal portraits your clients will love! $29.95 list, 8½x11, 128p, 60 images, order no. 1681.

Corrective Lighting and Posing Techniques for Portrait Photographers

Jeff Smith

Learn to make every client look his or her best using lighting and posing to conceal real or imagin flaws—from baldness, to acne, to figure flaws. $29 list, 8½x11, 120p, full color, 150 photos, order 1711.

Basic Digital Photography

Ron Eggers

Step-by-step text and clear explanations teach y how to select and use all types of digital came Learn all the basics with no-nonsense, easy to foll text designed to bring even true novices up to sp quickly and easily. $17.95 list, 8½x11, 80p, 40 b photos, order no. 1701.

Make-up Techniques for Photography

Cliff Hollenbeck

Step-by-step text paired with photographic ill trations teach you the art of photographic make Learn to make every portrait subject look his or best with great styling techniques for black & w or color photography. $29.95 list, 8½x11, 120p, full-color photos, order no. 1704.

Professional Secrets of Natural Light Portrait Photography

Douglas Allen Box

Learn to utilize natural light to create inexpensive hassle-free portraiture. Beautifully illustrated w detailed instructions on equipment, setting select and posing. $29.95 list, 8½x11, 128p, 80 full-co photos, order no. 1706.

Portrait Photographer's Handbook

Bill Hurter

Bill Hurter has compiled a step-by-step guide portraiture that easily leads the reader through phases of portrait photography. This book will be asset to experienced photographers and beginr alike. $29.95 list, 8½x11, 128p, full color, 60 pho order no. 1708.

Basic Scanning Guide For Photographers and Other Creative Types

Rob Sheppard

This how-to manual is an easy-to-read, hands workbook that offers practical knowledge of sc ning. It also includes excellent sections on mechanics of scanning and scanner selection. $17 list, 8½x11, 96p, 80 photos, order no. 1702.

Professional Marketing & Selling Techniques for Wedding Photographers

Jeff Hawkins and Kathleen Hawkins

Learn the business of successful wedding photography. Includes consultations, direct mail, print advertising, internet marketing and much more. $29.95 list, 8½x11, 128p, 80 photos, order no. 1712.

Traditional Photographic Effects with Adobe® Photoshop®

Michelle Perkins and Paul Grant

Use Photoshop to enhance your photos with hand-coloring, vignettes, soft focus and much more. Every technique contains step-by-step instructions for easy learning. $29.95 list, 8½x11, 128p, 150 photos, order no. 1721.

Master Posing Guide for Portrait Photographers

J. D. Wacker

Learn the tchniques you need to pose single portrait subjects, couples and groups for studio or location portraits. Includes techniques for photographing weddings, teams, children, special events and much more. $29.95 list, 8½x11, 128p, 80 photos, order no. 1722.

Beginner's Guide to Adobe® Photoshop®

Michelle Perkins

Learn the skills you need to effectively make your images look their best, create original artwork or add unique effects to almost any image. All topics are presented in short, easy-to-digest sections that will boost confidence and ensure outstanding images. $29.95 list, 8½x11, 128p, 150 full-color photos, order no. 1732.

Professional Techniques for Digital Wedding Photography

Jeff Hawkins and Kathleen Hawkins

From selecting the right equipment to building an efficient digital workflow, this book explains how to best make digital tools and marketing techniques work for you. $29.95 list, 8½x11, 128p, 80 full-color photos, order no. 1735.

Photographer's Lighting Handbook

Lou Jacobs Jr.

Think you need a room full of expensive lighting equipment to get great shots? Think again. Learn how light affects every subject you shoot and how, with a few simple techniques, you can produce the images you desire. $29.95 list, 8½x11, 128p, 130 full-color photos, order no. 1737.

The Art of Black & White Portrait Photography

Oscar Lozoya

Learn how master photographer Oscar Lozoya uses unique sets and engaging poses to create black & white portraits that are infused with drama. Includes lighting strategies, special shooting techniques and more. $29.95 list, 8½x11, 128p, 100 full-color photos, order no. 1746.

Beginner's Guide to Digital Imaging

Rob Sheppard

Learn how to select and use digital technologies that will lend excitement and provide increased control over your images—whether you prefer digital capture or film photography. $29.95 list, 8½x11, 128p, 80 full-color photos, order no. 1738.

Professional Digital Photography

Dave Montizambert

From monitor calibration, to color balancing to creating advanced artistic effects, this book provides photographers skilled in basic digital imaging with the techniques they need to take their photography to the next level. $29.95 list, 8½x11, 128p, 120 full-color photos, order no. 1739.

Group Portrait Photographer's Handbook

Bill Hurter

With images by over twenty of the industry's top portrait photographers, this indispensible book offers timeless tips for composing, lighting and posing dynamic group portraits. $29.95 list, 8½x11, 128p, 120 full-color photos, order no. 1740.

Lighting and Exposure Techniques for Outdoor and Location Portrait Photography

J. J. Allen

This book teaches photographers to counterbalance the challenges of changing light and complex settings with techniques that help you achieve great images every time. $29.95 list, 8½x11, 128p, 150 full-color photos, order no. 1741.

Toning Techniques for Photographic Prints

Richard Newman

Whether you want to age an image, lend a shock of color, or improve the archival stability of your black & white prints, the step-by-step instructions in this book will help you realize your creative vision. $29.95 list, 8½x11, 128p, 150 full-color/b&w photos, order no. 1742.

The Best of Nature Photography

Jenni Bidner and Meleda Wegner

Have you ever wondered how legendary nature photographers like Jim Zuckerman and John Sexton create their captivating images? Follow in their footsteps as these and other top photographers capture the beauty and drama of nature on film. $29.95 list, 8½x11, 128p, 150 full-color photos, order no. 1744.

The Best of Wedding Photography

Bill Hurter

Learn how the top wedding photographers in the industry transform special moments into lasting romantic treasures with the posing, lighting, album design and customer service pointers found in this book. $29.95 list, 8½x11, 128p, 150 full-color photos, order no. 1747.

Success in Portrait Photography

Jeff Smith

No photographer goes into business expecting to fail, but many realize too late that camera skills alone do not ensure success. This book will teach photographers how to run savvy marketing campaigns, attract clients and provide top-notch customer service. $29.95 list, 8½x11, 128p, 100 full-color photos, order no. 1748.

Photographing Children with Special Needs

Karen Dórame

This book explains the symptoms of spina bifida, autism, cerebral palsy and more, teaching photographers how to safely and effectively capture the unique personalities of these children. $29.95 list, 8½x11, 128p, 100 full-color photos, order no. 1749.

Professional Digital Portrait Photography

Jeff Smith

Digital portrait photography offers a number of advantages. Yet, because the learning curve is so steep, making the tradition to digital can be frustrating. Author Jeff Smith shows readers how to shoot, edit and retouch their images—while avoiding common pitfalls. $29.95 list, 8½x11, 128p, 100 full-color photos, order no. 1750.

The Best of Children's Portrait Photography

Bill Hurter

See how award-winning photographers capture the magic of childhood. *Rangefinder* editor Bill Hurter draws upon the experience and work of top professional photographers, uncovering the creative and technical skills they use to create their magic portraits. $29.95 list, 8½x11, 128p, 150 full-color photos, order no. 1752.